DeWain Valentine

Concave Circle, 1969

Cast polyester resin, 92" x 92" x 12"
Courtesy of the artist
(Not in exhibition)

radical past: contemporary art & music in pasadena, 1960-1974

With contributions by

Jay Belloli

Linda Centell

Michelle Deziel

Suzanne Muchnic

Peter Plagens

Jeff von der Schmidt

Exhibition presented by

Armory Center for the Arts

Alyce de Roulet Williamson Gallery,
Art Center College of Design

Norton Simon Museum of Art

New Pasadena Gallery, One Colorado

Southwest Chamber Music

The exhibition and catalogue are made possible by the generous support of Victoria Solaini Baker, Michael J. Connell Foundation, Institute of Museum and Library Services, Pasadena Art Alliance, and The Andy Warhol Foundation for the Visual Arts.

Published by Armory Center for the Arts,
145 North Raymond Avenue, Pasadena, California 91103,
and Art Center College of Design,
1700 Lida Street, Pasadena, California 91103.

ISBN 1-893900-00-2

Distributed by:
RAM Publications & Distribution
Bergamot Station
2525 Michigan Avenue, A-2
Santa Minica, California 90404
phone: 310-453-0043 fax: 310-264-4888

Editor: Karen Jacobson
Art Direction: Leslie Baker
Design: Gina Phelps
Printing: Typecraft Inc., Pasadena, California

Exhibition Dates

Southern California Art: 1969–1974
Armory Center for the Arts
February 7–April 11, 1999

Influences: Selections from the Contemporary Collection of the Norton Simon Museum
Alyce de Roulet Williamson Gallery,
Art Center College of Design
February 7–April 11, 1999

The Museum: Highlights from the Collection and Archives of the Pasadena Art Museum
Norton Simon Museum of Art
February 7–May 9, 1999

Pasadena Scene, 1960–1974: Photographs of Contemporary Art in Pasadena
New Pasadena Gallery, One Colorado
February 7–April 11, 1999

Music from a Radical Past: Seven Concerts Honoring the Encounters Series
Southwest Chamber Music (at the Armory Center for the Arts and Zipper Concert Hall, Colburn School of Performing Arts)
February 14–April 13, 1999

Curators

Jay Belloli
Director of Gallery Programs
Armory Center for the Arts

Michelle Deziel
Exhibition Curator
Norton Simon Museum of Art

Stephen Nowlin
Director, Alyce de Roulet Williamson Gallery
Art Center College of Design

Jeff von der Schmidt
Artistic Director
Southwest Chamber Music

Contents

Roy Lichtenstein

Big Modern Painting (For Expo '67), 1967

Oil and magna on canvas, three panels,
120" x 360" overall
Norton Simon Museum of Art,
Gift of the artist and Mr. Leo Castelli, 1967

Preface and Acknowledgments

Get back, get back, Get back to where you once belonged. — John Lennon and Paul McCartney

In Pasadena, California, dominating the corner of Orange Grove and Colorado Boulevards, the Norton Simon Museum of Art's building houses a particular tale—and a certain history—that still contains a restless energy. Down the street, in the chic commercial Old Town district, a square block of shops and restaurants now called One Colorado contains a chapter of that history. So do ghosts in the building on Los Robles that houses the Pacific Asia Museum, three-quarters of a mile farther east, as does the lengthening shadow of the Armory Center for the Arts, half a mile northeast. Farther away, Los Angeles's Museum of Contemporary Art has its own connection to this tale, and farther still, a steady glow of activity from Southern California's galleries and working artists illuminates its legacy.

This is the story of how contemporary art came to Southern California in that decade of upheaval, the 1960s. Imagine the upscale boutiques of Old Pasadena in an earlier incarnation as low-rent storefronts housing pawn shops, bars, and thrift stores and upstairs lofts providing inexpensive square footage for artists who wanted to be in the orbit of the Pasadena Art Museum (PAM), that place over on Los Robles where Marcel Duchamp played chess with a nude Eve Babitz. Down in L.A. the county fathers were in a snit over Ed Kienholz's *Back Seat Dodge '38,* in which a wire-mesh couple embraced too closely for moral comfort. Meanwhile, at PAM the irreverent iconography of pop art was introduced to the Southland, and boundaries of musical convention were being broken by the likes of John Cage and Karlheinz Stockhausen in the Encounters Series. In Venice Beach a couple of galleries had sprung up, and some artists were making art out of surfboard materials and car paint. The notion of the electronic in art and music was born, and something new called video was being talked about. The shindigs over at the museum were becoming as legendary for the shocking outfits of the opening-night crowd as they were for the art being debuted. A consciousness was afoot, and a sprawling, undefined urban metropolis was beginning to acquire an artistic identity, thanks in no small degree to something that was going on in Pasadena.

Today that history lives behind other edifices, erected and renovated by the demands of new ideas and new realities. Different players have emerged locally, such as Art Center College of Design, which occupies a 175-acre campus in the hills above the Rose Bowl, and Southwest Chamber Music, which is the ensemble-in-residence at the Armory, preserving the tradition of collaboration between music and art fostered in the 1960s by PAM and Encounters. The former Los Robles site of PAM now houses the Pacific Asia Museum. The Armory Center, itself a descendant of PAM's education department, occupies renovated exhibition and studio space not far from One Colorado. The Norton Simon Museum reflects its namesake's penchant for an older, more classical tradition, while preserving, exhibiting, and lending the polemical PAM collection.

Many of the characters in this tale have scattered, but their time in Pasadena is an echo that can still be heard and, in this case, also seen. We decided to bring this radical past out of the storeroom and reassemble its many and sometimes missing parts. To accomplish this somewhat daunting goal, five organizations joined forces to share physical spaces as well as human resources. We knew at the outset that even our five institutions couldn't present work by all of the artists and composers who had been active in Pasadena or had shown at the Pasadena Art Museum between 1960 and 1974. What emerged was *Radical Past: Contemporary Art*

and Music in Pasadena, 1960–1974, a four-venue art exhibition and seven-concert musical retrospective that attempt to reconstruct this small but vital piece of our history.

The original exhibition concept for *Radical Past* grew out of Jay Belloli's desire to document the artists who had worked in Pasadena in the 1960s and 1970s. The sheer size of such an undertaking suggested a collaborative effort from the beginning, and over lunch with fellow curator Stephen Nowlin, the notion of engaging the Norton Simon Museum of Art and its PAM collection holdings was initiated. Through the efforts of Director of Art Sara Campbell and with the support of Jennifer Jones Simon, the Norton Simon Museum agreed to lend works from the collection and participate in the exhibition as well.

With extraordinary generosity, Victoria Solaini Baker funded the exhibition, along with the Michael J. Connell Foundation, Institute of Museum and Library Services, Pasadena Art Alliance, and The Andy Warhol Foundation for the Visual Arts. We are deeply grateful for their support. At the Armory, the staff, board, and Gallery Subcommittee have been extremely supportive of the show, particularly Executive Director Elisa Crystal, who created the ancillary exhibition *Process as the Muse: Fifty Years of Artists Teaching Art.* Linda Centell, gallery program coordinator, and Jennifer Gunlock, gallery assistant, have worked beyond expectations on this project, as have the installation crew, particularly Seth Kaufman, installation contractor. At Art Center, President David Brown has been enthusiastic about this exhibition from the beginning, and Associate Curator Julian Goldwhite and the installation staff have worked hard to present the show. At the Norton Simon Museum, Curator Gloria Williams has been exceptionally supportive and helpful and has provided invaluable assistance. The work and knowledge of Registrar Andrea Clark, who was assisted by Surbhi Bajaj, have been essential to the exhibition's success. Photographer Antoni Dolinski, Administrative Assistant Kimberly Gilhooly, and Museum Store Manager Andrew Uchin have provided additional assistance. Southwest Chamber Music Executive Director Jan Karlin and Program Manager Inka Bujalski have made it possible to fund and present a memorable series of programs evoking the Encounters Series. At One Colorado, Kate Straus, marketing director, and Robin Faulk, marketing consultant, have enthusiastically participated in and assisted the exhibition.

The Archives of American Art office at the Huntington Library made essential research materials available during the development of the exhibition and catalogue. We are grateful to catalogue authors Suzanne Muchnic and Peter Plagens for their knowledgeable and insightful essays. Editor Karen Jacobson has provided excellent assistance in developing the catalogue text. Leslie Baker, assisted by Gina Phelps, has designed a beautiful catalogue, invitation, and banners, as well as the Armory exhibition *Process as the Muse.* Black-and-white digital imagery was produced by Alexis Gertz. The catalogue was printed at Typecraft, Inc., Pasadena, under the care of Harry Montgomery. We also thank Leonard Pangus at Typecraft for his exceptional work on the color separations. Many people have provided photographs for the catalogue, and Jerry McMillan has been particularly generous in this regard.

We are very grateful to the museums, collectors, and galleries who lent to the exhibition and provided materials for the catalogue. Some of the past curators and directors of the Pasadena Art Museum, particularly Walter Hopps and Tom Leavitt, offered advice and assistance. Finally, we want to express our warm appreciation to the artists for their enthusiastic participation. They have been generous with their time, personal records, and efforts, some of them creating installations or performances at the Armory especially for the show.

This exhibition demonstrates the abilities of the artists who lived, exhibited, emerged, and matured in Pasadena during those fondly remembered years, as well as the vision of the curators, directors, and patrons who supported them.

Jay Belloli, *Director of Gallery Programs, Armory Center for the Arts*
Michelle Deziel, *Exhibition Curator, Norton Simon Museum of Art*
Stephen Nowlin, *Director, Alyce de Roulet Williamson Gallery*
 Art Center College of Design
Jeff von der Schmidt, *Artistic Director, Southwest Chamber Music*

No More Nutburgers

Suzanne Muchnic

The 1960 United States census certified an obvious fact: greater Los Angeles was no longer number three. With a population of 6,690,000, the city and its environs had moved ahead of the Chicago area and were second only to metropolitan New York, whose teeming masses numbered 10,545,000. What's more, the growth rate of the new number two was more than five times that of number one. During the 1950s New York boosted its population by 10 percent, while Los Angeles shot up a whopping 53 percent.

Taking its pulse in July 1960, as the city prepared to host the Democratic National Convention, the *New York Times* reported that "the visible evidence of Los Angeles' graduation from the status of a transitory curiosity" was even more impressive than the statistics. L.A. boasted "the Big League baseball team that once graced Brooklyn; a 'bedroom' community (the San Fernando Valley) analogous to Brooklyn, grown since World War II from a few thousand inhabitants to 1,000,000; mile upon peripheral mile of subdivisions comprising an ever-expanding sea of suburbs; and the roar of airplanes betokening one of the world's busiest international air terminals."

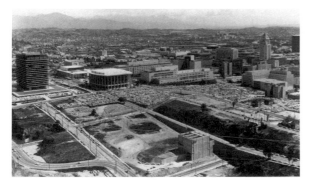

Los Angeles in 1967.

Still, there were less desirable "symptoms of britches-busting"—smog, insufficient public transportation, and a shortage of water—prompting the reporter to ask: "Why did the people ever settle in this arid area? Why have they kept on gravitating here in such a number as to make this the center of nearly half the state's population?" The answer: "wide open spaces."

"It's the story of the better mousetrap," a Los Angeles industrialist told the reporter. "In our personnel recruitment ads in Eastern papers, we don't stress money. We talk 'California living'—a product you can only get by coming here. Everyone who comes makes jobs for five others, to build his house, take in his washing, sell him groceries. People have been talking for sixty years about the collapse of the Los Angeles 'boom.' But every year brings more evidence that Los Angeles is here to stay."[1]

The art scene in Los Angeles was expanding rapidly as well, albeit with painful self-consciousness. In the second issue of *Artforum,* established in 1962 in San Francisco as an avant-garde magazine devoted to art on the West Coast, three New York transplants—painters Lorser Feitelson and Arnold Schifrin and artist-dealer Paul Gerchik—spoke of L.A. as a pleasant but provincial city in a state of transformation. "The world has shrunk to a point where we know almost immediately what is going on in Rome, London, Paris and New York," Gerchik said. Collectors in search of important paintings still headed for New York or Paris, but the cluster of galleries that had sprung up along La Cienega Boulevard attracted crowds, particularly at Monday night openings. "There is something happening on this street that is extraordinary," he said. "We have taken people away from the cowboy operas on TV on a Monday night. We have made it a pleasurable, interesting, exciting event."[2]

Jules Langsner, the most respected art critic in Los Angeles, took the discussion further in "America's Second Art City," published in 1963 in *Art in America,* a New York-based magazine with an international readership. "In the space of a half-a-dozen years the status of Los Angeles in the art community has changed from the home of the nuts who diet on nutburgers to a lively and vital center of increasing importance on the international art map, having become in the interim the country's second city with regard to caliber and number of galleries, collectors, museum activities, and creatively prodigal painters, sculptors and printmakers," he said.[3]

The seminal—and now legendary—commercial showcase was the Ferus Gallery, established in 1957 by artist Edward Kienholz and curator Walter Hopps. The gallery's original stable reads like a who's who of L.A. artists: John Altoon, Billy Al Bengston, Wallace Berman, Craig Kauffman, Ed Moses, and Kenneth Price. Larry Bell, Robert Irwin, and Ed Ruscha were among later additions who also rose to prominence. Ferus was located on La Cienega amid "some two dozen first-rate galleries" noted by Langsner. But even in those days the gallery scene was scattered, with smaller clusters in Beverly Hills and Westwood and on the Sunset Strip and Wilshire Boulevard.

The galleries presented "top-notch shows," Langsner said:

Los Angeles dealers now range far and wide to secure exhibitions by major artists from around the country, and from Europe, Japan and Latin America. At this writing, one-man shows in the galleries include drawings by Joan Miro; the American debut of abstract sculptor Arnoldo Pomodoro of Milan; the welded automobile "junk" sculpture by New York artist John Chamberlain; the first retrospective of works by Jasper Johns, the New York pioneer of "new realism"; the first American exhibition of Kandinsky's pupil Otto Nebel of Bern, Switzerland; the first viewing of new lithographic series by Mexican artist Jose Cuevas; as well as exhibitions of paintings by Joan Brown and Arthur Okamura of San Francisco, Raymond Parker of New York, Kenneth Callahan of Seattle, and James McGarrell of Indiana. Along with shows by these out-of-town artists, current exhibitions include efforts by such prominent local talents as sculptor Pegot Waring, and painters Billy Al Bengston, Roberto Chavez, Helen Lundeberg, Paul Sarkisian, Frederick Wight and Emerson Woelffer.[4]

Another vital component of the burgeoning art scene was Tamarind Lithography Workshop, founded in 1960 by artist June Wayne with a Ford Foundation grant. The workshop not only revived the art of lithography, it also functioned as a magnet, drawing artists from all over the world to create prints. Gemini G.E.L. (Graphic Editions Limited), a spin-off of Tamarind, was destined to play an even larger role in bringing influential artists to Los Angeles. Gemini was established late in 1965 by Kenneth Tyler, the former master printer at Tamarind, and two businessmen with an interest in art: Sidney Felsen, an accountant, and Stanley Grinstein, who owned a forklift company. The production facility began operating in 1966 and began publishing innovative prints and multiples by Jasper Johns, Ellsworth Kelly, Roy Lichtenstein, and Robert Rauschenberg, among many other artists, all of whom sojourned in Los Angeles while their work was in process.

Meanwhile a new generation of art collectors was developing, with a passion and commitment that would also lead them to become major supporters of local museums. Industrialist Norton Simon, America's preeminent postwar collector, bought his first paintings in 1954. At his death in 1993 he had amassed twelve thousand objects, ranging from old master paintings to impressionist artworks to Indian and Southeast Asian sculpture. His sister and brother-in-law, Marcia and Frederick R. Weisman, also built a large collection, but they concentrated on modern and contemporary art.

Others who began acquiring contemporary art in a big way during the 1960s include Robert Halff, Philip and Beatrice Gersh, Stanley and Elyse Grinstein, and Robert Rowan. They educated themselves both at home and on their travels, in galleries and museums, and occasionally in fellow enthusiasts' living rooms. In the late 1950s and early 1960s aspiring collectors in search of guidance and enlightenment often enrolled in an influential UCLA Extension course, "Looking at Modern Painting." Accompanied by a textbook written by UCLA professors, the class was taught in the students' homes by art historians

and curators, including James Demetrion, Henry Hopkins, and Walter Hopps, who subsequently distinguished themselves as museum curators and directors.

In the early 1960s Los Angeles also was "in the midst of a cultural fund-raising and building spree,"[5] as Langsner put it. Ground was broken in 1962 for the construction of the Los Angeles County Museum of Art on Wilshire Boulevard, following a five-year effort to create a separate institution for the art collection that was housed at the Los Angeles County Museum of History, Science, and Art in Exposition Park. Like most big projects that depend upon community funding, the push to build LACMA was fraught with arguments over the architecture and power plays among donors, but the new museum opened in 1965, accompanied by considerable fanfare and national press coverage. LACMA's charismatic director, Richard Fargo Brown, was, however, already at odds with the trustees. He resigned under duress within a few months of the opening and moved to Fort Worth,

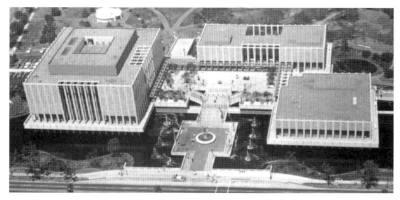

The original buildings of the Los Angeles County Museum of Art.

Texas, where he directed the Kimbell Art Museum. Brown's dream of commissioning a distinguished architect to build a modern landmark had been thwarted in Los Angeles; in Fort Worth he presided over one of architect Louis Kahn's last major commissions, which is regarded as one of the world's most beautiful art museums.

During Brown's Los Angeles tenure, one of his victories was to hire Maurice Tuchman, a young curator of twentieth-century art from the Guggenheim Museum in New York. Some museum patrons who favored other candidates resisted Tuchman's appointment,

Llyn Foulkes, Maurice Tuchman, Judy (Gerowitz) Chicago, Lloyd Hamrol, 1964.

but they soon had to admit that he raised the profile of the museum by originating traveling exhibitions and presenting provocative programs, including *Abstract Painters: New York School*, *American Sculpture of the Sixties*, a survey of Kienholz's assemblages (which became a *succès de scandale* when some Los Angeles County Supervisors objected to Kienholz's raunchy subject matter and threatened to close the show), and *Art and Technology*, an enormously complex collaborative venture.

Meanwhile in Pasadena a move was under way to build a new facility for the Pasadena Art Museum, located in the Chinese-style building now occupied by the Pacific Asia Museum. Hopps became curator of the Pasadena Art Museum in 1962 and staged an international coup the following year, when he organized and presented the first major retrospective of Marcel Duchamp's work. Within a few years Hopps had compiled a distinguished exhibition record, including a show of pop art and timely presentations of many major artists' work. He became acting director of the museum in 1963 and then director from 1964 to 1967.

Hopps was skeptical of the building plans, but he was overruled by trustees, who were determined to build a grand edifice in Carmelita Park, on city-owned land that had been the original home of the museum. The new institution opened in 1969. The trustees had planned a $3 million building, but costs escalated and they ended up with a $5 million structure they could not afford to program and maintain, in addition to a $1.5 million debt on the building.

The exhibition program attracted international attention. To launch the new building and effectively announce that it was positioning itself as a rival of New York's modern and contemporary art institutions, the

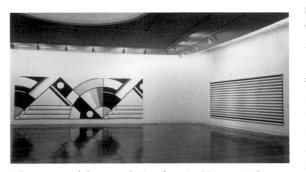

The opening exhibition at the Pasadena Art Museum, 1969.

museum presented two inaugural shows: *Painting in New York, 1944–1969* and *West Coast, 1945–1969.* During the next five years the museum showed a wide variety of art, including avant-garde and historic photography, Indian and Southeast Asian sculpture from the Avery Brundage collection, and Japanese prints from the Frank Lloyd Wright collection. The program focused primarily on contemporary art, however. Exhibitions of the works of influential East Coast artists—including a show of sculpture and drawings by Donald Judd, a memorial for Eva Hesse, the first major survey of Agnes Martin's painting, and a presentation of Andy Warhol's serial objects and images—won critical approval in the art press. Southern California artists—including John Altoon, Larry Bell, Robert Heinecken, Craig Kauffman, John Mason, and DeWain Valentine—also received prominent billing.

But the museum was in trouble even before its doors opened. In 1971 a desperate search for additional sources of revenue began, but every attempt failed. Finally, in 1974, Norton Simon agreed to take charge of the museum, on his terms. He would assume financial responsibility and pay off the debt. For a period of five years he would use 75 percent of the exhibition space for his collection and the remaining space for the Pasadena Art Museum's collection.

Alfred E. Esberg, then president of the board, tried to put the best face on the agreement. "The original purpose in building a museum is to provide a home for a great collection and the benefit of all the people in the community. It must be a secure home," he told a *Los Angeles Times* reporter. "This merger will do that. We've given the contemporary community a major try to support the museum. Its supporters and sympathizers did not rise to the occasion. A great experiment didn't work." Without the help of Simon, "the museum would have probably closed down within the year," he said.[6]

The news was a blow to artists and museum supporters, many of whom were still smarting from the loss of *Artforum,* which had moved to Los Angeles in 1965 but packed up and went to New York in 1967. Claes Oldenburg, whose work had been the subject of a retrospective exhibition at the museum, summed up the gloomy mood in the *New York Times.* The Pasadena debacle was "just another step in the disappearance of L.A. as a contemporary art scene," he told a reporter.[7]

Despite such predictions, greater Los Angeles has evolved into a major art center. The Norton Simon Museum of Art, as it is now called, is an extraordinary cultural asset. Supporters of the former Pasadena Art Museum eventually got the institution they wanted in the Museum of Contemporary Art, founded in 1979 in downtown Los Angeles. The Los Angeles County Museum of Art has expanded considerably. And the Getty Center—with its new museum, research facilities, and outreach programs—has added an element of stability, as well as a tourist attraction. The fertile period from 1960 to 1974 has yielded a bountiful harvest.

Notes

1. "Report from Nation," *New York Times,* 10 July 1960, 4.

2. "Feitelson, Gerchick, Schifrin," *Artforum,* July 1962, 22, 25.

3. Jules Langsner, "America's Second Art City," *Art in America,* April 1963, 127.

4. Ibid., 128.

5. Ibid., 129.

6. William Wilson, "Simonizing of the Pasadena Art Museum," *Los Angeles Times,* 29 April 1974, 8.

7. Grace Glueck, "Simon Control of Museum Stirs Coast," *New York Times,* 14 May 1974, 38.

Lasting Achievements:
The Pasadena Art Museum

Jay Belloli

To Walter Hopps

The Pasadena Art Museum had a long period of growth, a spectacular flowering, and a swift decline. Its history began during the museum boom of the 1920s, which followed the first great period of American museums, the 1880s, when the Metropolitan Museum of Art in New York, the Art Institute of Chicago, and other institutions were founded in the larger, more established cities. The 1920s saw the establishment of museums in a second tier of cities—Houston, Omaha, Cincinnati, and Pasadena, which, in 1924, became home to the Pasadena Art Institute.[1]

In the 1920s Pasadena was already a bedroom community for downtown Los Angeles and a city of socially acceptable wealth, populated by old Southern California families, lawyers, doctors, and wealthy winter visitors from the East or Midwest like the Gambles (of Procter & Gamble). Early in its history, Pasadena also became associated with the arts. Here Henry and Charles Greene created some of the greatest Arts and Crafts buildings in the country, and other architects, as well as painters and writers, lived in the community or nearby, participants in what was called the Arroyo culture. On the west side of Los Angeles, a great new American industry—motion pictures—was being developed. Economically it would soon eclipse anything or anyone on the east side of the city, creating a permanent secondary status for Pasadena that would have long-term repercussions for its fledgling museum.[2]

Despite its extraordinary growth in the 1920s, Southern California was still a cultural backwater. The great collections that were formed in the region—like those of the Arensbergs, Huntingtons, or Edward G. Robinsons—concentrated on European art, whether of the old master, impressionist, or modern periods. Pasadena's museum catered to the tastes of its moneyed patrons, showing landscape, still-life, and figurative works by local artists.

The rise of fascist dictatorships in Europe in the 1930s brought a number of the most gifted writers, composers, and film directors (Thomas Mann, Arnold Schoenberg, and Fritz Lang, to mention just a few) to the pleasant climate of Southern California. The presence of these emigrés would ultimately have a profound effect on the region's cultural life. As the 1930s passed and the United States entered World War II, the Pasadena Art Institute continued to present art to the public. In 1942 the institute merged with a younger organization, the Pasadena Museum Association. It moved from its original home in a Victorian mansion in Carmelita Park, on Colorado Boulevard near Orange Grove, to Grace Nicholson's Chinese House and Emporium at 46 North Los Robles Avenue.

In 1947, at the start of the postwar baby boom, the institute, with the financial and organizational assistance of the Pasadena Junior League, introduced a Junior Museum, with exhibitions, art classes taught by professional artists, and performing-arts programs specifically geared to children. The program was exceptionally innovative for its time and quickly gained national recognition, serving as a model for other local organizations (such as the City of Los Angeles, with its Junior Art Center). The institute continued to show work by local artists and—under a new director—some more venturesome art, including the work of Man Ray.

These years saw a fortuitous conjunction of events at the institute: the hiring of more innovative directors, the development of a groundbreaking education program, and a sudden change of artistic focus.

The key event in the institute's history was the bequest, in 1953, of the Galka Scheyer collection.[3] The German-born Scheyer was an intimate of the European artists Lyonel Feininger, Alexei von Jawlensky, Wassily Kandinsky, and Paul Klee, whom she represented, as the "Blue Four," in the United States from 1924 until her death in 1945. She settled in Hollywood in 1930, and in addition to selling works of art of behalf of her friends, she gave lectures and organized exhibitions of their work, primarily on the West Coast. The Scheyer bequest included more than 450 works that she hadn't wanted to or had been unable to sell. The gift was to the people of California, and under the directorship of John Palmer Leeper the Pasadena Art Institute secured the bequest. In one gesture, the museum had the most important collection of works by Feininger, Jawlensky, and Klee in the United States, in effect becoming one of the few modern art museums in the country.

Galka Scheyer, about 1930.

It is important to realize how suspect modern art was in the United States in the early 1950s. With the exception of New York's Museum of Modern Art, several small museums, and one or two modern art departments of major Eastern or Midwestern museums, few institutions were collecting or exhibiting the art of this century. Pasadena's reaction to the Blue Four bequest was ambivalent. The institute's president requested that another gift, insignificant by comparison, be announced at the same time so the public didn't feel the museum was "going modern."[4] Nevertheless, in 1954 the institute reorganized to focus on acquiring and exhibiting modern art, particularly works created after 1945, and changed its name to the Pasadena Art Museum. But it kept its options open. In addition to a collection of Asian art, there was a significant and a growing collection of prints, including works by old masters.

In 1955, with a grant from Los Angeles County, the museum hosted the first California Design exhibition. Although modeled on the design department at the Museum of Modern Art in New York, this exhibition program was more populist in nature, which ultimately led to a philosophical battle within the museum. The disagreement was a classic one in the museum world. The design show attracted the largest crowds of any exhibition, but it did not focus, as the museum's other exhibitions did, on major California figures like Charles and Ray Eames. Therefore, in the eyes of the directors and fine art curators, it did not meet the qualitative standards they felt the museum should maintain.

W. Joseph Fulton, who served as director from 1953 through 1957, carried out the guidelines emphasizing art since 1945 with an excellent abstract expressionist exhibition. And important modern artists associated with Southern California—including Clinton Adams, Leonard Edmondson, Helen Lundeberg, John McLaughlin, and Richards Ruben—all had had one-person exhibitions at the museum during the mid-1950s. As fine as the programs were, the museum barely had enough money to operate. Volunteers—including members of the Art Alliance, a very effective women's support group formed in 1955—made it possible for the museum to operate until its closing years later.

Thomas Leavitt, Llyn Foulkes and Walter Hopps at the opening of Foulkes's exhibition, Pasadena Art Museum, 1962.

It was with the arrival of Thomas Leavitt as director in 1957, followed by an informal association with Walter Hopps in 1960, that the museum began to bring to fruition its commitment to contemporary art. Leavitt's ambitious vision was to present exhibitions that would locate the museum on the national and international

stage, and discussions about a new building soon began. He organized an extensive Robert Motherwell exhibition, which helped make the museum an important focus of Southern California art world attention.[5] Increasingly dealers, collectors, and artists began to show up at openings, which were also attended by members of the Art Alliance and representatives of Pasadena society. Ironically most of the artists and major collectors now came from L.A.'s west side, but they still regarded Pasadena as the place to be seen.

Leavitt also wanted to recognize Richard Diebenkorn, arguably California's greatest twentieth-century painter. So in 1960 he organized a Diebenkorn retrospective, assisted by Walter Hopps. Hopps, with Edward Kienholz, founded the now-legendary Ferus Gallery in Los Angeles in 1957. At Ferus, Hopps presented a new generation of Southern California contemporary artists, including John Altoon, Billy Al Bengston, Wallace Berman, Robert Irwin, Craig Kauffman, and Ed Moses. Not surprisingly, the Ferus artists began to appear on the Pasadena Museum exhibition schedule, often with solo shows.[6] Leavitt wanted a fine art curator, and by 1962 Hopps was formally in that position.

As Hopps describes it, he and Leavitt formulated a policy that the museum would present historical exhibitions of twentieth-century art "whenever we could afford it."[7] The first of these would be a show, organized by Hopps, of work by Kurt Schwitters, the great German collagist. The museum would aggressively pursue the major modern and contemporary shows from the important New York museums. But, as Hopps put it, "when it came to living … artists … no distinction [would be] made between who was east, or west, or European and that, without stating it publicly, for every non-Californian we'd do, there would be a comparable California show."[8] This comprehensive approach to Southern California art encouraged many tendencies, including assemblage, pop, hard-edge abstraction, and light and space. Acquisitions, which increased during this period, reflected this inclusiveness, and the museum began to amass a California collection that was impressive in its scope. The policy also recognized that, by the early 1960s, Los Angeles was becoming the country's second center for contemporary art. Its exhibition and acquisition policies helped make the Pasadena Art Museum an important influence in defining what Southern California art was, both for the region and nationally.

The exhibitions that emerged from the museum's focus were astonishing. Hopps's 1962 Schwitters retrospective became the first twentieth-century historical show organized in Southern California to travel to another state. The Pasadena Art Museum became one of the few modern art museums or museum departments sending exhibitions out into the world, the others being the Albright-Knox Art Gallery in Buffalo and Walker Art Center in Minneapolis.

At the same time as the Schwitters exhibition, Hopps organized *Directions in Collage: A Survey from California* with about 120 artists from throughout the state.[9] These shows were quickly followed by *New Painting of Common Objects,* a very early survey of pop art, which, true to Hopps's beliefs, included the finest artists from both coasts. In adjacent galleries was a survey of East and West Coast abstract expressionist art. The museum staff, still miniscule despite some additions, worked long hours to realize exhibitions that were extraordinary in scope and scale, with the Art Alliance doing much of the rest of the work and fund-raising needed to keep the museum going.

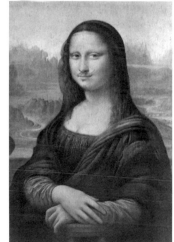

The increase in professional staff was the key to another defining moment in the history of the Pasadena Art Museum, the 1963 Marcel Duchamp exhibition, the first retrospective of the artist's work ever organized. As Hopps tells it, Leavitt suggested that he do a Jasper Johns show (which was

Marcel Duchamp, "L.H.O.O.Q. or La Joconde", 1964, replica of 1914 original.

presented later). Instead, Hopps proposed the Duchamp show and, with Leavitt's approval, set about doing it.[10] Hopps had an uncanny ability to recognize the greatness of artists and their influence on their

time. Duchamp was the early twentieth-century figure who defined the artistic dialogue that began in the mid-1950s, and the show put the museum on the map, propelling it and its curator into the international limelight.

Leavitt left the museum before the Duchamp exhibition opened, and in the midst of organizing the show, Hopps assumed the directorship. Leavitt had made him "very conscious of the circumstances of the Scheyer bequest,"[11] and the result was, from 1963 through 1967, retrospectives of each of the Blue Four artists, which were either organized by Pasadena (Jawlensky and Feininger), organized with another institution (Klee), or taken from another museum (Kandinsky). Hopps brought in James Demetrion, curator of the Jawlensky show, as curator of art in 1964. In addition, the museum embraced a proposal from noted Los Angeles music figure Leonard Stein to organize a contemporary music program, the Encounters Series. It began in 1964 and, until its move to the California Institute of Technology in 1971, featured the most recognized American and European composers of the period. In 1965 the museum, under Hopps's direction, was selected by the United States Information Agency to organize the São Paulo Bienal, a high honor for a small museum and its curator.

Larry Poons, Barnett Newman and Walter Hopps at opening of São Paulo Bienal exhibition at Smithsonian Institution, 1966.

About the time of the 1965 opening of the new Los Angeles County Museum of Art, the idea of a new building for the Pasadena Art Museum resurfaced. Having left the Carmelita Park site decades earlier, the museum had the right for a period of years to reclaim the land from the city and construct a new building there, and time was running out. Further, with the museum's new visibility, there was sentiment among some board members that there should be a new building as well. At the end of the "go-go" 1960s, when "all things seemed possible,"[12] this optimism seemed justified. The head of the board, Harold Jurgensen, accepted Hopps's idea of soliciting proposals from several respected Southern California architects: Charles Eames, Craig Ellwood, John Lautner, and Richard Neutra and Robert Alexander. At the last minute, Hopps decided that there should be a Pasadena architect on the list, and Thornton Ladd and John Kelsey were added. When Jurgensen realized that Thornton Ladd's mother was wealthy, he decided that there would be no review, got the board's approval, and Ladd and Kelsey did the design that resulted in the current Norton Simon Museum of Art building.[13] The lasting irony is that, in spite of their desire for an impressive building to match their internationally recognized exhibitions, the board chose local architects of modest reputation, who gave them a poorly designed museum building that became a key factor in the institution's financial downfall.

The demands of doing the São Paulo Bienal led Hopps to take a leave of absence, and James Demetrion began to run the museum. John Coplans, who had been associated with *Artforum* and the University of California, Irvine, took on publications and curatorial responsibilities. Hopps continued to organize exhibitions, including a show of recent paintings by Frank Stella and the first Joseph Cornell survey, but he was faced with a design for a building that he could not support. The professional and personal pressures on him were finally too much, and he was hospitalized because of a "psychotic break."[14] The new board president, Robert Rowan, asked for Hopps's resignation. Rowan and his then-wife, Carolyn, who lived in Pasadena, were major collectors of contemporary American art, and he was considered essential to the realization of the new museum building.

The controversy over Hopps's departure added to the museum's problems. Several major collectors from the west side—Donald Factor, Gifford Phillips, and Fred and Marcia Weisman—had been encouraged to join the Pasadena board. But none of them was given substantial authority, and this weakened their commitment to the museum. Meanwhile the new curator of modern art at the Los Angeles County

Museum of Art, Maurice Tuchman, was mounting ambitious contemporary shows, stealing the thunder from the Pasadena Art Museum.

As planning for the new building continued, the pace of the museum's programming did not abate. Demetrion was occupied with running the museum and developing the new building, and Coplans organized the shows, including Roy Lichtenstein's first major museum exhibition (1967) and *Serial Imagery* (1968), which documented a then-expanding twentieth-century approach to artistic composition. The museum continued to take major exhibitions organized by other museums. In a sense, the approach that Hopps and Leavitt had established— a balance between showing historical European art and major East and West Coast contemporary work—was maintained

Pasadena Art Museum, 1969.

The museum's finances, however, always fragile, were getting worse. The board was proceeding with the construction of the new museum despite operating difficulties and insufficient funds for construction, and seemed unaware of how expensive a larger building would be to operate.[15] Furthermore, patrons whose interests lay outside the arena of modern art were being encouraged to donate to the building campaign with expectations that their interests would be addressed. Demetrion resigned before the new building opened. Thomas Terbell, a well-meaning banker on the board and (with his wife, Melinda) an important collector, was appointed director, and Coplans became curator of art.

A series of ill-informed decisions dealt a severe blow to the museum. With Coplans's approval, portions of the postwar collection were sold off, including works by well-known American and Southern California artists,[16] as well as pieces that were purchased from the Pasadena Society of Artists and San Gabriel Valley juried exhibitions,

resulting in the loss of part of the institution's heritage. At the same time, Southern California artists who had benefited from the museum's exhibitions in earlier years were asked to give major works to the collection in celebration of the new building. Against this backdrop came a powerful insult. For the opening exhibition at the new building, Alan Solomon, an Easterner from the Jewish Museum in New York, organized *Painting in New York, 1944–1969*. This was not only a stunning demonstration of the museum's sense of cultural inferiority regarding Southern California art but also a seeming repudiation of the curatorial philosophy that had helped establish its reputation in the first place. When Coplans discovered what Solomon's show was to be, he organized a companion exhibition, *West Coast, 1945–1969*. As good as Coplans's show was, it was much smaller than Solomon's, and a number of the L.A. area artists who had shown at and given work to the museum were understandably alienated.

There was a basic incompatibility between Coplans and the board and volunteers, and he was asked to leave.[17] From this point on, changes came more and more rapidly. Terbell was asked to resign the directorship not long after the arrival in 1970 of William C. Agee, formerly of the Museum of Modern Art in New York, as director of exhibitions and collections, and Agee became director. The museum's financial crisis was deepening, but the curators continued to organize groundbreaking exhibitions. A two-week presentation of the work of composer John Cage early in 1970 (part of the Encounters Series) was followed by the noted Richard Serra environment of huge cut logs, Coplans's Andy Warhol retrospective, and exhibitions by Coplans's former assistant, Barbara Haskell, of work by Sol LeWitt and Claes Oldenburg. Eudorah Moore, who had organized many of the California Design exhibitions, returned to the museum in 1971 and mounted a show of work by Magdalena Abakanowicz. The museum continued to show the work of many important Southern California artists, such as Peter Alexander, Craig Kauffman, and DeWain Valentine.

One of the achievements of this period was the introduction of the next generation of artists from the region. Judy Chicago presented

one of her large pyrotechnic performances at the entrance to the museum. Young L.A. photographers were featured in several exhibitions. Two important exhibitions curated by Haskell in 1972 featured a number of the Southern California artists who became dominant figures of the 1970s, such as John Baldessari.

As 1972 and 1973 passed, the activity continued, but the reality of the museum's finances had become unavoidable, despite the efforts of Agee and the new board president, Alfred Esberg. Increasingly, shows were drawn from the permanent collection or from local collectors.

In March 1973 the museum formally changed its name to the Pasadena Museum of Modern Art to more accurately reflect the nature of its programming since the mid-1950s. But it was too late. For years the museum had hedged its position, trying to be too many things to too many people, and the result was that a number of individuals felt betrayed when it didn't fulfill what they saw as its function.[18] And, as Agee described it, "there was finally an incompatibility between the avant-garde nature of the museum and the … basically conservative nature of the community."[19] No one on the board could or would rescue the institution. In April 1974 the museum changed its name back to the Pasadena Art Museum, and Norton Simon accepted the board's request to intervene and save it financially. In its fiftieth year the museum closed, reopening in 1975 as the Norton Simon Museum of Art.

Despite its demise, the Pasadena Art Museum's influence is still felt in the art world today. It proved that Southern California had the artists, the curatorial talent, and the collectors to create a museum of modern and contemporary art. And the intense level of energy and activity didn't stop in 1974. For more than twenty years the museum had shown modern and contemporary art to artists and the interested public in the region. It became a training ground for some of the finest curators and directors of that generation. The Art Alliance, which had worked for almost two decades to staff and raise money for the museum, went independent as the Pasadena Art Alliance and is still raising funds for arts organizations in Pasadena and nearby communities. The Fellows of Contemporary Art, an organization of wealthy patrons established at the museum by volunteer extraordinaire Martha Padve, has gone on to be a significant force in the presentation of exhibitions of Southern California art. The Men's Committee still exists, as the Pasadena Committee for the Arts. The Art Workshop program, established in the 1940s, has become the Armory Center for the Arts, a nationally recognized community art center with an exhibition program focusing on Southern California art. Further, the Pasadena Art Museum's building was transformed into the Norton Simon Museum of Art, which still houses the region's greatest collection of old masters. In the words of Walter Hopps: "This is the second most important urban area in America in the twentieth century. For twenty-five years of that, Pasadena was its base for modern art."[20]

Notes

1. Walter Hopps, interviewed by Joanne L. Ratner, Oral History Program, University of California, Los Angeles, 1990, 105.

2. Ibid.

3. Ibid., 15.

4. Martha B. Padve, "A Case Study of Museum Decision-Making," term paper, the Claremont Colleges, Claremont, California, 1973, 4.

5. Hopps interview, 50–51.

6. A number of the important artists of the period—including John Altoon, Frederick Hammersley, and Paul Sarkisian—also taught classes in the museum's Art Workshop program.

7. Hopps interview, 27.

8. Ibid., 28.

9. The California collage show, if any more proof was needed, showed the politically repressive side of Southern California during the period. One of George Herms's collages in the show included an old American flag. There were protests in front of the museum. The museum held firm, but since the flag was stolen almost immediately, the controversy ended quickly. See Hopps interview, 42.

10. Ibid., 45.

11. Ibid., 46.

12. William C. Agee, interviewed by Joanne L. Ratner, Oral History Program, University of California, Los Angeles, 1990, 14.

13. Hopps interview, 68.

14. Ibid., 90–91.

15. The classic discussion of the development of the building, and the reasons for the closing of the museum, is John Coplans's "Pasadena's Collapse and the Simon Takeover: Diary of a Disaster," in *Provocations: Writings by John Coplans,* ed. Stuart Morgan (London: London Project, 1996).

16. Hopps interview, 127.

17. Agee interview, 8.

18. Ibid., 10, 12. The Pacific Asia Museum, located in the Pasadena Art Museum's original building on North Los Robles, became the creation of those individuals interested in Asian art.

19. Ibid., 9.

20. Hopps interview, 107.

Crown City Chronicle

Peter Plagens

There's a danger in institutionalizing a long-term, and fairly visceral, phenomenon like the loose community of artists who happened to work in Pasadena at various times from 1960 to 1974. An exhibition runs the risk—as the critic Thomas McEvilly said about the Museum of Modern Art's infamous 1984 *Primitivism* show—of wiping the blood off the objects. And the wine, we'd add. While an academic, longer-view catalogue essay can be removed and unfeeling, the closer view (through a participant's eyes and memory) can be narrow, partisan, hyperbolic, and self-congratulatory. The closer view also unconsciously presupposes that the time one spent in Pasadena (1970 to 1978, in my case) coincided with a golden age the best confluence of artists on the way up, artists who'd already arrived, and, of course, the neighborhood ambiance at its peak. But this presupposition isn't wholly my personal delusion. As Merwin Belin (who was raised in Norwalk, California; was a Pasadena artist from 1972 to 1984; and later worked in New York and Washington, D.C., before moving back to the Left Coast) puts it, "To this day, if someone asks me where I'm from, I say Pasadena."

Taking the shorter view also makes one prone to kvetch about the awful things that have happened in Pasadena in the years since. Well, in this case it's only one thing: the gentrification—indeed, the touristification—of Old Town. But, as any of us who live in the middle of cities know, or should know, things change. What is now a trendy restaurant used to be a sporting-goods store, which used to be a sculptor's studio. But the sculptor's studio used to be a warehouse, which used to be a stable, which used to be a farmer's field, which used to be an Indian encampment, which used to be untouched wilderness. Nobody has ever been guaranteed immunity from loss and nostalgia.

James Turrell, Porter-Powell, *1967, at Pasadena Art Museum.*

If there's anything, however, about which artists, especially former Pasadena artists, are entitled to be nostalgic, it's the Pasadena Art Museum (née the Pasadena Art Institute in 1924 and re-rechristened the Pasadena Museum of Modern Art in 1973). You can't underestimate the effect of the museum, not only on the artists who worked in the city during the period covered by this exhibition but also on the Southern California art world as a whole. The Mark Tobey retrospective in 1960 helped give impetus to a nascent Southern California taste (perhaps born in opposition to the bombastic melodrama of abstract expressionism as it filtered down to Los Angeles from its second home in San Francisco) for smaller, more intimate, fussier art objects. (An exhibition of Robert Irwin paintings, also in 1960, reinforced this.) Two years later, *New Painting of Common Objects* gave Southern Californians an early, in-the-flesh look at pop art, in which the intimacy (but perhaps not the fussiness) was transmuted by irony. Finally, in 1967, the area's "fetish finish" proclivity did an Aimee Semple Macpherson and ascended ethereally heavenward in James Turrell's landmark exhibition of projected light pieces. Important California artists of other persuasions, who were not yet fully visible on the New York radar—Richard Diebenkorn, John Mason, John McLaughlin, Hassel

Smith, and Emerson Woelffer—were given major shows in the early 1960s. And, at the same time, the museum showed such standard-bearers of the New York scene as Jasper Johns, Donald Judd, Roy Lichtenstein, Kenneth Noland, Jules Olitski, Larry Poons, and Frank Stella on a scale that we couldn't get from the "pickup" shows, often featuring smaller or secondary works, at the local commercial galleries.

No other show, however, had the tectonic-plate-moving effect of the 1963 Marcel Duchamp retrospective. Painter Walter Gabrielson remembers being in the Pasadena Art Museum during the exhibition when a rather stereotypical Pasadena matron walked in. Just a few steps into the show, she stopped and announced loudly, "This exhibition is a public disgrace." Then she walked out. In general, the ratio of artists who recall the sight of Duchamp, live in the gallery, playing chess with a nude Eve Babitz (one of Ed Ruscha's girlfriends and, later, a novelist), to the handful who might have been around when the photograph was snapped is probably greater than that of people who "remember" seeing Babe Ruth calling his shot in the 1932 World Series to those who were actually present that day in Wrigley Field. If Dada wasn't already rampant in Southern California (remember, Man Ray worked in Los Angeles), it certainly was after this show closed. The Duchamp show gave a shot in the arm to local assemblagists whose work was already on that track, and it converted a lot of artists who weren't. As Psycho-psychological, and coherently narrative as it is, the work of Llyn Foulkes, who worked in Pasadena then, is almost impossible to conceive of without the precedent of the cerebral, subversive-of-narrative Duchamp. And Belin says, "It played a big role in my deciding to become an artist at all." ("You must have been in the fifth or sixth grade," I reminded him. "I had the picture before it was taken," he replied, in true Duchampian fashion.)

But, as the old adage says, the decline of any organization begins when it moves into the new building. That proved true in spades for the Pasadena Art Museum, when it moved in 1969 from its dank, dilapidated but wonderfully unpretentious and viewer-friendly quarters on North Los Robles Avenue to a god-awful new building designed by a local architect, Thornton Ladd, whose main asset seemed to be his mother's social connections. The new edifice was majorly bad: narrow corridors that could have served as a set for *The Andromeda Strain,* curved walls unfriendly to the installation of art, complicated ceiling motifs—they looked like giant cowls for jet engines—that competed with the art for attention, and leaks that caused the wood floors to swell and bubble. (When the museum put up a little protective fence around one of the damaged areas, some of us artists thought it was a "piece.") But an even worse problem was that so much money had been poured into the building that there was practically nothing left over to run it with.

Still, even in its precipitous decline, the museum mounted several exhibitions as influential, if not more so, than the shows on North Los Robles. The 1970 Richard Serra "big log" exhibition showed us how a real art-world tough guy could bully a museum into becoming a foil for an artist as well as a venue for his work. The show of emerging conceptual artist Allen Ruppersberg several months later was the first show of slacker art, *avant la lettre.* The Eva Hesse memorial exhibition right before the museum's demise demonstrated that a hero of feminism could also

Richard Serra exhibition, Pasadena Art Museum, 1970.

be a magnificently agendaless artist. And *Fifteen Los Angeles Artists* (which included some who worked in Pasadena) in 1972 set the working list of rising stars for almost the next ten years. The Pasadena Art Museum's program was all the more crucial for artists because Los Angeles's Museum of Contemporary Art was still a gleam in a few collectors' eyes, and the Los Angeles County Museum of Art lay strangely fallow in terms of art that artists were interested in seeing.

That's the longer view, sort of. The short view was largely through the windshield of my Naples yellow 1964 Ford Falcon station wagon as I drove on the far side of the speed limit to get from the San

Fernando Valley, where I lived, to my Pasadena studio. My (and Walter Gabrielson's) place was only a day studio, a second-floor on the corner of Fair Oaks and Union, so it didn't get me completely out of the Valley. For Scott Grieger, his live-in studio did. "It meant something to me to get out of the Valley," he says. "I'd been in it since I was in junior high and had put about 800,000 miles on various vehicles going back and forth … without encountering a major cultural institution." Although Grieger didn't move to Pasadena specifically to be near the museum, he—like many immigrant artists from anyplace in the L.A. Basin outside the sliver of cultureland on the west side—liked knowing that it (along with Pasadena's great public library, its civic auditorium, and the Huntington Library, in adjacent San Marino) was there, just in case.

Grieger was by no means the first modern artist in Pasadena. As far back as the turn of the century (nineteenth to twentieth, that is), Pasadena began to foster a homegrown, somewhat bohemian artistic culture. Along the hillsides of the Arroyo Seco, as it ran south toward Los Angeles, clots of artists, potters, writers, and poets gathered together to form a kind of Southern California version of the Arts and Crafts movement. But while those earlier artists might have set up shop because of the beauty of the landscape or the chance to mix in particular artistic and literary "circles," most of us who arrived in the 1960s and 1970s wanted only cheap working space and a sense of urban "place" that was missing from most of the rest of Southern California.

When I got there in 1970, Judy Chicago (already famous—as artists go—for minimal sculpture and later for starting the women's art program at Fresno State College); her partner, sculptor Lloyd Hamrol; and Llyn Foulkes were the senior artistic residents. Then there was the group living in the brilliantly eccentric curator Walter Hopps's foliage-enshrouded house on Orange Grove Boulevard. It included Bruce Nauman (who, even back then, could have settled anyplace he wanted to); his wife, Justine; painter Richard Jackson; Jackson's wife, Annie; and (as I recall) a lot of artists who were just passing through. We relative latecomers rented bare-bones but spacious and serviceable studios in Old Town. Peter Lodato, a classmate of Grieger's at Cal State,

Northridge, tried the de rigueur artists' neighborhood of Venice and found it too expensive. Karen Carson (who tipped Walter and me off to our place) wanted a leg out of UCLA graduate school. Ron Linden had decided he couldn't survive artistically as a professor in (literally) Peoria, Illinois. He'd taken a visiting gig at the University of Southern California and had found his capacious place on Raymond Avenue

Peter Zecher and other artist in a Pasadena studio.

almost by accident. Belin and Cynthia Maughan, who were then graduate students at Cal State, Long Beach, found a huge space (formerly the original Pasadena library) worth making the long commute for. Hap Tivey was ensconced in a strange old hotel south of Colorado Boulevard, where he could build his experimental color hemispheres in peace. And, to curve almost full circle back to where Grieger was coming from, Max Cole arrived in flight from suburban stultification in Arcadia, in search of something more "real." Even Nauman, whose work was still predicated on just hanging around a solitary space thinking up oddball things to do and document, got himself a grungy upstairs workplace a few doors down from Walter and me on Union Street.

The quasi-official historian of California, Kevin Starr, describes Pasadena as a community (during the Great Depression) "priding itself on its Anglo-Saxon ancestry … aloof, genteel, upper-middle-class."[1] What we artists experienced—and loved—were the dilapidated commercial remnants of that civilization. The spacious old brick buildings contained great, boxy caves perfect for studios. The somewhat down-at-the-heels coffee shops like La Dru's were perfect for long, inexpensive Saturday breakfasts arguing about the many deaths of painting. We had bars like Chromo's, the Loch Ness Monster, and, cheapest of them all (beers for a quarter, same price as the coin-operated pool table), the Club 11 on Union Street. It was the first thing demolished to make room for the Parsons engineering empire's headquarters, which was, in

turn, one of the first things to signal "there goes the neighborhood" in the mid-1970s. Besides the wonderful Pasadena Public Library, we had

Ron Linden in his studio.

a readily available porno theater (one side for straight movies, the other for gay ones) a bit farther north on Fair Oaks. And we had "bums," as we still politically incorrectly called them in those days. Cole remembers: "I could hear wine bottles breaking in the alley at all hours of the night." Linden says: "There were winos galore in the park up Raymond. I'll never forget my father visiting me from Chicago when my boys were still little kids. He said, 'Do you know what you're doing to your sons?'"

Let's not forget the air. At times between May and November, the air in Pasadena was like Tabasco sauce for the eyes and lungs. Gabrielson used to say that the scary thing was not the August afternoon when everything more than two blocks away disappeared into a wall of beige. Rather, it was the beautiful midwinter day when the smog cleared out and Mount Lowe and Mount Wilson were starkly visible again—as startling as if a brightly painted movie set had been erected during the night.

Yes, Pasadena was cheap and "real," but was there anything more to it? A style, maybe, a general look, an attitude? Truth be told, our community was a pretty far cry from, say, the 1930s "School of Paris," with its center-of-the-world self-confidence, roster of international luminaries, and house style (surrealism, in several variations). Neither did we have the drunken sense of revolution and two-fisted anti-effeteness that suffused New York abstract expressionism in the 1940s and early 1950s. Perhaps something like a counter-Venice was closer to it. Venice art had a look: the "fetish finish" for which the Los Angeles scene had become known. Linden recalls: "Nauman took me to some openings in Venice. I met Larry Bell and a few others, sitting around smoking cigars. The thought of a painting of some motorcycle heraldry on wrinkled metal was moderately interesting, but I was more interested

in what Bruce was doing, a kind of plain-wrap provocative. Besides, I'm a reverse snob, and I felt more comfortable in a more working-class environment, like around our studios." Lodato boils it down to this: "There were the Hollywood sort of guys—Billy Al Bengston et al.—in Venice, and the existentialists in Pasadena." Belin says that once he and a few pals were having lunch in Pasadena with a visiting Venice artist, who said he had to leave to get back to the gourmet Charmer's Market in Venice before it closed. Belin pointed out that there was a Safeway not far away. "*Me*, go to Safeway?" the Venice artist responded.

Alas, there was no "Pasadena look," nothing remotely comparable to the commonality of, say, Bell's boxes and DeWain Valentine's resin rings. Cole painted grids influenced by Agnes Martin. Carson alternated between big, zippered meta-paintings and witty, surreal, social-comment charcoal drawings. Gabrielson's stuff went against *everybody's* grain, taking off from the likes of Thomas Hart Benton and Grant Wood as well as Gerald Scarfe. Grieger satirized blue-chip contemporary art in modes as various as Barnett-Newman-striped plaster footballs and bodily "impersonations" of such icons as a Robert Irwin disc painting. Lodato was very early into installations, but of a peculiarly minimal sort. Belin initially toyed with neon, formed an art-rock band called Auto da Fe, and then went wise-ass conceptual. Maughan made videos and was included in a Documenta. I painted big abstractions, often sourly reviewed as being too New York.

What we had—from an international star like Nauman, through all of us laboring in the middle, to a few folks who flared briefly and then just disappeared from the scene—was a good place to work and a place to feel at home with other artists, without the pressure that comes along with being part of a trendy scene. As Gabrielson says, "A lot of artists go to a place where success is supposedly implied in the location. That wasn't Pasadena." We were just there to work and to take advantage of the way it all felt. And for a while it felt pretty good.

Notes

1. Kevin Starr, *Endangered Dreams: The Great Depression in California* (New York: Oxford University Press, 1996), 322.

Music from a Radical Past:
The Encounters Series, 1964–1973

Jeff von der Schmidt

To Leonard Stein

"It could only have happened in the Age of Aquarius."
Karen Monson, Los Angeles Times, *February 25, 1969*

For much of the twentieth century, music and the visual arts enjoyed a significant familial resonance, to a degree that was unequalled during the preceding two centuries. Composers and artists were fervently changing the vocabulary—both technically and emotionally—of forms that had, with all due respect to the proletariat, only recently become the province of any working middle class.

The cliché of twentieth-century music history, so common critical tabloid theory goes, involves an entire generation of power-hungry postwar composers who destroyed everything in their path to promote an aesthetic and music that no one wanted to hear, while controlling, with totalitarian power, the very fabric of concert and academic life. Though the notion that composers, in particular the iconoclastic ones, exercised absolute power over concert or academic life is on shaky ground (does anyone really believe that the orchestras of the time were awash in new music?), conventional critical tabloid wisdom continues to promote the dogma that contact with the audience was never present, significantly eroded, or altogether lost.

Leonard Stein, 1960s.

Did this really happen in the 1960s? Were the Aquarians cold fish? Or does the conventional wisdom regarding the modern music of the time mask emotional and intellectual ignorance of a changed world?

This backdrop and its questions are important as we assess the impact of the Encounters Series at the Pasadena Art Museum and California Institute of Technology (Caltech) between 1964 and 1973. For the success of the Encounters Series confounds the strongly held belief that modern music was at its core alienating to the public. And Leonard Stein, director of the series, was the perfect combination of Moses and Aron, part ideologue, part drumbeater for the new aesthetic of the time. Through Stein's tenacious persistence, nearly every important contemporary composer appeared in Pasadena during this period.

The following composers were presented at or personally graced the Encounters Series—Luciano Berio, John Cage, David Tudor, Harry Partch, Arnold Schoenberg, Morton Feldman, Morton Subotnick, Karl Kohn, Charles Ives, Don Ellis, Karlheinz Stockhausen, William Kraft, George Heusenstamm, Toshi Ichiyanagi, La Monte Young, Ingolf Dahl, Henri Pousseur, Earle Brown, Ernst Krenek, W. O. Smith, Milton Babbitt, Pierre Boulez, Iannis Xenakis, Mel Powell, Larry Austin, Olivier Messiaen, Roger Reynolds, Elliott Carter, Terry Riley, Lou Harrison, Toru Takemitsu, György Ligeti, Leon Kirchner, Paul Chihara, Mario Davidovsky, and Salvatore Martirano—a distinguished list of the most compelling musical minds of the second half of the twentieth century. One struggles to find any other public series during the 1960s and early 1970s that so concerned itself with access and outreach.

From a humble beginning in 1964, the Encounters gave an important face and personality to the music of the time. It is not an exaggeration to point out that the immense success of the Meet the Composer program is anticipated in the Encounters Series by a generation. The Rug Concerts, the most successful innovation during Pierre Boulez's tenure at the New York Philharmonic in the 1970s, also owe a debt of gratitude to Stein's concept. Encounters events were often repeated on the same evening, with programs at 7 and 9 p.m. The *Los Angeles Times* reported that the line went around the block for both presentations of Karlheinz Stockhausen in 1966.

Leonard Stein provided the most straightforward description of these events in a letter to composer Steve Reich on April 22, 1972: *First of all, Encounters is neither a "concert" series nor a "lecture" series. It is only an attempt to present the composer as person and musician to a very eager and generally well-educated audience (including many young people). Since, in most cases, some of the music of the composer is already known through recordings, we like to hear something directly from the composer (in as informal a discussion as he likes) about his music (perhaps he can illustrate—with performers—how he goes about his work). Of course, then, we also want to hear some of his work performed—the newer they are the better. So far, this format has worked out very well with the many different kinds of composers and their many different ways of presentation.*

Stein, who was Schoenberg's assistant at the University of California, Los Angeles, and the University of Southern California, had been asked by associates of the Coleman Chamber Music Association, the nation's oldest presenter of chamber music, to produce a series that would address the neglect of new music. The first program took place on April 13, 1964, at the Pasadena Art Museum and featured Cathy Berberian and Luciano Berio.

After this pilot event Stein set his sights in 1965 on three of the most iconoclastic figures of the twentieth century: John Cage, Harry Partch, and Arnold Schoenberg. The Schoenberg program ended the season on April 12, 1965, and produced the world premieres of thirty

of Schoenberg's canons, while Partch was represented on February 8, 1965, with his *Surrogate Kithara Diamond Marimba* and a screening of films about his work. The opening was a concert of David Tudor and John Cage.

Nineteen sixty-six saw an expansion from three composers to five. Morton Feldman, Karl Kohn, Morton Subotnick, and jazz icon Don Ellis were presented, along with an evening devoted to Charles Ives. Feldman appeared on February 28, 1966, with *King of Denmark* and *Vertical Thoughts*. On March 20 Subotnick offered his *Prelude No. 3 for Piano and Tape, Tarot No. 3 for Viola, Tape and Visual Projection,* and electronics. Kohn, of Pomona College, essayed a program of his works on April 27. On May 16 there was an evening of Ives, including the *Concord Sonata* and the *Second Violin Sonata*. The third season ended on June 12 with jazz trumpeter Ellis.

The 1966–67 season marked the first time the Encounters Series resembled an annual series, although it still started in December. The composers for the year included Luciano Berio, Pierre Boulez, William Kraft, and Karlheinz Stockhausen. Stockhausen was teaching at the University of California, Davis, and agreed to make the trip south to discuss his *Mikrophonie I and II, Telemusik* and to run a film of his large-scale work *Momente* for Encounters on December 11, 1966. Kraft, who was also a member of the Los Angeles Philharmonic, brought his *Encounters II* and *Double Trio* on February 26, 1967. An evening of five *Sequenzas* by Luciano Berio occurred on April 9, and Boulez discussed his *Éclat* on June 4.

Karlheinz Stockhausen at Disneyland, 1966.

The fifth season continued at the Pasadena Art Museum in 1967–68 with Toshi Ichiyanagi, La Monte Young, Ingolf Dahl, and

La Monte Young.

Henri Pousseur. Ichiyanagi began the season December 3 with a mixture of Japanese and Western instruments. Young presented *Map of the 49's Dream of the Eleven Sets of Galactic Intervals Ornamental Lightyears Tracery* on four successive nights, January 28–31. This was followed by the music of Ingolf Dahl. Dahl questioned Stein regarding finding a good violinist for new music: "Does Larry [Loesser] know one from the Heifetz class who is not such a prima donna that he is incapable of playing complex new chamber music (stupid question, I'm afraid it answers itself)?" At season's end Pousseur oversaw his unique opera Votre Faust, with its text by Michel Butor, on March 3.

"I'm here to have fun. Life has made me miserable for forty-three years, and now I'm going to make it miserable." Composer and clarinetist extraordinaire William O. Smith voiced this quintessential 1960s sentiment at the Encounters Series during the season of 1968–69. This season, the last at the Pasadena Art Museum's Los Robles address, also included Earle Brown, Ernst Krenek, and Milton Babbitt. Brown began the season on December 8, 1968, with *Novara, Available Forms II, Modules,* and *Corroboree.* Krenek journeyed in from Palm Springs to discuss his *Quintina* and *Horizon Circled.* Smith appeared on February 23, 1969, with clarinet and tape projector, to great critical acclaim. And Babbitt ended the season with electronic compositions and performances by famed violinist Robert Gross and pianist Peter Hewitt of his *Sextets.*

For the November 21, 1969, opening of the new Pasadena Art Museum at the corner of Orange Grove and Colorado (now the site of the Norton Simon Museum of Art), Stein concocted a grand plan, one literally meant to raise the roof. His idea involved antiphonal brass ensembles placed on either side of the entrance, and he commissioned works for the occasion by William Kraft and George Heussenstamm. Augmenting these new works were antiphonal brass choir pieces from the Renaissance by Samuel Scheidt and Venetian master Giovanni Gabrieli. The prestige of the opening brought coverage from the *New York Times* and eventually a recording of the Kraft work. The season continued with John Cage, Yuji Takahashi, Iannis Xenakis, Mel Powell, and Larry Austin.

In 1970–71 the series was given at both the Pasadena Art Museum and Caltech's Beckman Auditorium. Stein wisely wanted to steer clear of the financial difficulties besetting the museum, and received significant cooperation from Caltech, including the assistance of Professor Paco Lagerstrom and Jerry Willis, director of public events. The composers for the 1970 series were indeed a very intriguing mix: Olivier Messiaen, Roger Reynolds, Elliott Carter, and Terry Riley, who had recent-

John Cage, Encounters program at Pasadena Art Museum, 1970.

ly catapulted into notoriety with *In C.* Yvonne Loriod, Messiaen's wife, played the entire *Vingt regards sur l'enfant Jésus* in October of 1970 at Beckman Auditorium. Reynolds, of the University of California, San Diego, offered his *I/O* at the Pasadena Art Museum, which was the last Encounters event at the museum. The Composers String Quartet offered the first and second string quartets of Elliott Carter. Riley brought keyboard studies, *A Rainbow in Curved Air,* and *Poppy Nogood and the Phantom Band.*

By far the largest undertaking of the Encounters Series was the presentation in the 1971–72 season of Lou Harrison's adult X-rated puppet opera *Young Caesar.* It featured an orchestra of instruments designed by Harrison, which he brought to Pasadena from his home in Aptos, California. By all accounts *Young Caesar* was a rousing success. Toru Takemitsu visited with *Voice, Eclipse,* and *Stanza I.* In March György Ligeti appeared with his *Ten Pieces for Wind Quintet.* The season ended with a visit by Leon Kirchner, with the *String Quartet No. 3* and

Music for Soprano, Chamber Ensemble and Tape. The final season in 1973 included Paul Chihara, Mario Davidovsky, and Salvatore Martirano.

Stein had tried to align Encounters with the emerging California Institute of the Arts Music Department, to no avail. The Pasadena Art Museum was soon to close its doors, and Caltech, a science institution, was not the ideal location for the series. But the twilight of Encounters is part of a larger picture. For the times were changing, the era's metaphor shifting imperceptibly, both artistically and politically.

The 1960s were suspicious of convention of any kind. In looking back at the history of the Encounters Series, one is struck by the plurality of diverse new musical vocabularies being presented and tolerated in new public relationships far removed from the elitist conventions of accepted musical life. The collaboration of Encounters with the Pasadena Art Museum and Caltech was—for one brief, shining moment—a new and democratic renaissance. The resultant informality did not betray the seriousness of the individual message of these quite different composers. Rather, it spoke to the necessary destruction of cultural elitism, a charge leveled against the arts to this very day. The contemporary music of the 1960s realized cultural inclusion with no particularly mandated political or ideological fervor. Perhaps the exit door from cultural elitism leads through the message of an Encounters Series, forcing one to go beyond the view that the contemporary music of that era had no emotional message and did not care about its public. The practical evidence, let there be no mistake, is emphatically to the contrary.

The desire to completely rewrite the vocabulary of music—be it through serial, technological, or minimalist means—contained nothing less than the seeds of a new social order, not the public alienation so often assumed. The proud and heroic successes of the Encounters Series enabled the Age of Aquarius to refresh music and its relationship to the audience with the energy, excitement, and humanism of genuine artistic exploration, in the process leaving Pasadena an enviable community endowment of the music of the twentieth century.

This article is excerpted from a longer essay on the Encounters Series. The author wishes to thank the Mandeville Special Collections at the University of California, San Diego, which houses the Leonard Stein Archives and Encounters Contemporary Music Series Archives.

The Museum: Highlights from the Collection and Archives of the Pasadena Art Museum

Norton Simon Museum of Art

Marcel Duchamp, *Poster for retrospective exhibition*

Pasadena Art Museum, 1963

Rico Lebrun, *Flood Figures,* 1961

Lithograph, Edition of 8. No. 1, 18 1/2" x 36 1/2"
Norton Simon Museum of Art, Museum Purchase,
Third Biennial Print Exhibition Purchase Award, 1961

Ben Talbert, *January 1, 1962 Triptych,* 1962

Woodcut on paper, artist's proof, 19 1/2" x 24 1/4"
Norton Simon Museum of Art, Museum Purchase,
Plant Fund, 1964

Frederick Sommer, *Paracelsus,* 1959

Silver gelatin print, 13 5/16" x 10 3/16"
Norton Simon Museum of Art, Gift of the artist, 1965

Edmund Teske, *Untitled,* n.d.

Silver gelatin print, 8 3/8" x 11"
Norton Simon Museum of Art, Gift of the artist, 1969

Leonard Edmondson, *Cabal,* n.d.

Color etching, Edition 5/50, 15 1/2" x 19 1/4"
Norton Simon Museum of Art, Museum Purchase,
Third Biennial Print Exhibition Purchase Award, 1961

Ynez Johnston, *The Black Pagoda IX,* 1966

Four-color lithograph, Tamarind Impression #1657, 30" x 22"
Norton Simon Museum of Art, Anonymous Gift, 1968

Charles White, *Untitled,* 1970 (detail)

Two brown lithographs, Tamarind Impression #2873
and 2873-State II, 22 1/6" x 16" each
Norton Simon Museum of Art, Anonymous Gift, 1972

William Brice, *Two Figures,* 1966

Five-color lithograph, Tamarind Impression #1810, 22" x 30"
Norton Simon Museum of Art, Anonymous Gift, 1968

Walter Askin, *The Balcony,* 1965

Oil on canvas, 45" x 43"
Collection of the artist

Jay DeFeo, *Daphne,* 1958

Oil, pencil and charcoal on paper mounted on canvas,
125 3/4" x 47 3/4"
Norton Simon Museum of Art, Gift of Mr. Sam Francis, 1965

June Wayne, *At Last a Thousand I,* 1965

Lithograph, Tamarind Impression #1000-A, 24" x 34"
Norton Simon Museum of Art, Anonymous Gift, 1969

Claire Falkenstein, *Regal Box,* n.d.

Glass and wire in metal box, 12" x 9" x 3 1/2"
Norton Simon Museum of Art,
Gift of Mr. and Mrs. Frederick R. Weisman, 1967

Emerson Woelffer, *Black and White,* 1959

Oil on canvas, 39 1/2" x 27 3/4"
Norton Simon Museum of Art,
Gift of Mr. and Mrs. Paul Kantor, 1966

Richards Ruben, *Claremont No. 55,* 1961

Oil on canvas, 70 1/4" x 83 1/2"
Norton Simon Museum of Art,
Gift of Mr. Robert A. Rowan, 1962

Edward Moses, *Rafe,* 1959

Oil and collage on canvas, 72 1/8" x 64 1/4"
Norton Simon Museum of Art,
Gift of Mr. Harris Newmark, 1968

John Altoon, *Ocean Park Series #8,* 1962

Oil on canvas, 81 1/2" x 84"
Norton Simon Museum of Art, Anonymous Gift, 1964

Sam Francis, *Pasadena Suite,* 1965

Four-color lithograph on Rives BFK paper, Edition 2/100,
Printed at Gemini G.E.L., Los Angeles by Kenneth Tyler,
23 1/2" x 15 3/4"
Norton Simon Museum of Art,
Gift of the Pasadena Art Alliance, 1966

Walasse Ting, *1 Cent Life,* 1964
(detail of print by Allan Kaprow)

Unbound book, 68 Lithographs and 61 poems,
Edition 1995/2000, 16 3/4" x 12" each page
Norton Simon Museum of Art,
Gift of Kornfeld and Klipstein, 1964

Clinton Adams, *Figure in Green,* 1969

Five-color lithograph, Tamarind Impression #2525, 22" x 24"
Norton Simon Museum of Art, Anonymous Gift, 1971

Lee Mullican, *The Wave,* 1969

Multi-color lithograph, Tamarind Impression #2824, 30" x 22"
Norton Simon Museum of Art, Anonymous Gift, 1972

Peter Voulkos, *Honk,* 1963

Bronze, 47" x 92" x 35"
Norton Simon Museum of Art, Museum Purchase
with funds from the Ford Foundation, 1963

Bruce Conner, *Couch,* 1963

Cloth-covered couch with wood frame, figure, cloth,
and paint, 32" x 70 3/4" x 27"
Norton Simon Museum of Art, Museum Purchase
with funds donated by Mr. David H. Steinmetz III and
an Anonymous Foundation, 1969

Edward Kienholz, *The Secret House of Eddie Critch,* 1961

Drop-front wood veneered writing desk containing plastic
doll parts, leather, wood, chicken wire, and animal fur,
24" x 32 1/4" x 13"
Norton Simon Museum of Art, Gift of Mrs. Sadye J. Moss, 1966

George Herms, *The Librarian,* 1960

Wood box, papers, brass bell, books, and painted stool,
57" x 63" x 21"
Norton Simon Museum of Art, Gift of Molly Barnes, 1969

Wallace Berman, *Untitled,* 1967

Verifax collage, 48" x 45 1/2"
Norton Simon Museum of Art,
Gift of Mr. and Mrs. Thomas Terbell, Jr.,
Mr. and Mrs. Allen O. Smith,
David H. Steinmetz III,
Margaret T. Cunningham, and
Mr. and Mrs. John S. Ferrier, 1967

Llyn Foulkes, *In Memory of St. Vincent School,* 1960

Oil, charred wood, plasticized ashes on blackboard, with chair,
66" x 72 1/4" x 12 1/2"
Norton Simon Museum of Art,
Gift of Dr. and Mrs. Harry Zlotnick, 1969

Billy Al Bengston, *Jet Inn Dracula,* 1968

Two-color lithograph, Tamarind Impression #2296-State II,
21 1/2" x 21 1/2"
Norton Simon Museum of Art, Anonymous Gift, 1972

Jerry McMillan, *Tree Bag,* 1966

Photographic construction, 13 3/4" x 5 7/8" x 3 1/4"
Norton Simon Museum of Art, Museum Purchase with funds
donated by Mr. Frederick G. Runyon, 1967

Edward Ruscha, *Annie, Poured From Maple Syrup,* 1966

Oil on canvas, 55" x 59"
Norton Simon Museum of Art,
Gift of the Men's Committee, 1966

Joe Goode, *Torn Cloud Painting,* 1971

Oil on canvas, 61 1/2" x 60"
Collection of the artist

Allan Kaprow *in his Pasadena Art Museum exhibition,* 1967

Installation photograph
Courtesy Norton Simon Museum of Art

Dennis Hopper, *Bomb Drop,* 1967-68

Neon sculpture, 4' x 11' x 4'
Courtesy of the artist
(not in exhibition)

Paul Sarkisian, *Untitled: For John Altoon,* 1970

Acrylic on canvas, 117 1/4" x 141"
Collection Milwaukee Art Museum, Gift of Friends of Art with
National Endowment for the Arts Matching Funds
(not in exhibition)

Mason Williams, *Bus Book,* 1967

Silkscreen on paper, Edition 2/200, box, 15" x 17 1/4" x 5 1/4"
Norton Simon Museum of Art, Gift of the artist, 1968

Richard Pettibone,
Roy Lichtenstein: Picasso's Woman with Flowered Hat, 1963

Silkscreen on canvas, Edition of 100, artist's proof,
7 5/8" x 6 1/4"
Norton Simon Museum of Art,
Gift of the Men's Committee, 1970

Kenneth Price, *Jivaroland Frog Cup,* 1968

Multi-color lithograph, Tamarind Impression #2495,
22" x 16 1/2"
Norton Simon Museum of Art,
Anonymous Gift, 1969

Vija Celmins, *Untitled,* 1970

Two-color lithograph, Tamarind Impression #2870,
20 1/4" x 29 1/4"
Norton Simon Museum of Art, Anonymous Gift, 1972

Robert Graham, *Untitled (Shower),* 1966

Assorted plastics, sand, pigmented beeswax, metal foils,
paint, wood, 14" x 36 3/8"
Norton Simon Museum of Art, Museum Purchase, 1966

Larry Bell, *Untitled,* 1962

Mirrored glass and chrome cube with spherical shapes on
five sides, 12 1/4" x 12 1/4" x 12 1/4"
Norton Simon Museum of Art, Purchase with funds donated
by the members of the 1967-68 Blum/Coplans class, Pasadena
Art Museum, 1968

John McLaughlin, *Untitled,* 1963

Lithograph, Edition 1/20, 18 1/2" x 21 3/4"
Norton Simon Museum of Art, Museum Purchase, 1965

Robert Irwin, *Untitled,* 1967-68

Acrylic lacquer on formed acrylic plastic, 54" diameter
Norton Simon Museum of Art, Museum Purchase,
Fellows Acquisition Fund, 1969

DeWain Valentine, *Concave Circle,* 1969

Cast polyester resin, 92" x 92" x 12"
Courtesy of the artist
(not in exhibition)

Craig Kauffman, *Untitled (Washboard Series),* 1965

Acrylic on vacuum formed plexiglas, 38 1/2" x 76 5/8" x 4 7/8"
Norton Simon Museum of Art, Gift of Vivian C. Kauffman, 1970

John McCracken, *Blue Post and Lintel I,* 1965

Plywood, fiberglass and lacquer, 102" x 32" x 17"
Norton Simon Museum of Art,
Gift of Mr. and Mrs. Frederick R. Weisman, 1967

Peter Alexander, *Mauve,* 1969

Cast polyester resin, 94 3/8" x 6 5/8" x 6 3/4"
Norton Simon Museum of Art,
Gift of the Men's Committee, 1969

John Mason, *Firebrick Sculpture – Pasadena,* 1974

Firebricks, 85 1/2" x 200" x 200"
Norton Simon Museum of Art, Gift of the artist, 1973

Clark Murray, *Untitled,* 1966

Acrylic on canvas, 46 1/2" x 33 1/2"
Collection of Hal and Mary Ann Glicksman
(shown at the Armory Center for the Arts)

Ron Davis, *Wyoming Slab,* 1974

Vinyl-acrylic copolymer and dry pigment on canvas, 108" x 174"
Norton Simon Art Foundation, Gift of Mr. Norton Simon

Southern California Art: 1969-1974

Armory Center for the Arts

Ron Cooper, *Corner Piece,* 1970

Polyester resin, fiberglass, pigment, 12' x 12" x 1/16"
Collection of the artist
(not in exhibition)

Peter Lodato, *Rouge,* 1972-81

Enamel and plaster on wall, 10' x 6'
Courtesy of the artist

Helen Pashgian, *Untitled,* 1969

Multicolored cast resin sphere, 10" diameter
Courtesy of the artist

Thomas Eatherton, *Move,* 1972

Iris print of installation of steel, plastic, cloth and incandescent
light, print by Duganne Atelier, installation 20' x 20' x 60'
Courtesy of the artist

Peter Zecher, *Cardboard Tripod VI,* 1974

Corrugated Kraft paper and paint, 45" x 45" x 45"
Collection of Mary Zecher

Jim Eller, *Red Container,* 1994 (replica of 1962 original)

Anodized aluminum and glass, 30" x 15" x 15"
Courtesy of the artist

John Outterbridge,

From Another Point of View, Containment Series, circa 1968

Stainless steel and wood, 84" x 26"
Collection of Joan and Fred Nicholas

Michael Todd, *Mia Chan XVII,* 1987

Lacquered steel, 92" x 81" x 30"
Courtesy of the artist

John Outterbridge, Michael Todd

Lloyd Hamrol,

Situational Construction for the Richmond Art Center, 1969

Red vinyl-coated glass cloth electrical sleeving supported
by nylon monofilament, 76" x 13' x 10'
(dimensions scaled down for Armory installation)
Courtesy of the artist

Judy Chicago,

Pasadena Lifesavers Red Series #5 (#2 illustrated), 1970

Sprayed acrylic lacquer on acrylic, 60" x 60"
Collection of the Grinstein Family

Terry Allen, *Brownie Bondage,* 1968

Oil pastel, scotch tape, graphite, and letter press on paper,
28 3/4" x 23"
Collection of Jo Harvey Allen

Michael Olodort, *Dancing Stone Hangar,* circa 1966

Pastel on paper, 19" x 25"
Collection of the Grinstein Family

Anthony Hernandez, *Untitled,* 1970

Silver gelatin print, 11 1/2" x 14 1/2"
Norton Simon Museum of Art, Gift of the artist, 1970

Gary Krueger, *Untitled,* 1970

Gelatin silver print, 8" x 10"
Courtesy of the artist

Robbert Flick,
Untitled, Excerpt, L.A. Book of the Dead, 1969-70

Silver gelatin print, 11" x 14 1/2"
Norton Simon Museum of Art, Museum Purchase, 1971

Leland Rice, *Wall Site,* 1973

Silver gelatin print, 20" x 16"
Courtesy of the artist

Robert Heinecken,

Fourteen or Fifteen Buffalo Ladies #3-II, 1969

Photo lithography and chalk, 17 7/8" x 14 1/8"
Norton Simon Museum of Art,
Gift of Mrs. Barbara St. Martin, 1969

Lewis Baltz, *Tract House #4,* 1971

Silver gelatin print, Edition 3/12, 5 3/4" x 8 7/8"
Norton Simon Museum of Art, Gift of the artist, 1971

Laddie John Dill, *The Glass Sentence,* 1971

Neon, 72" wide
Collection of Ariel Dill

Bruce Nauman, *Raw War,* 1970

Neon tubing with clear-glass tubing suspension frame,
from an edition of six, 6 1/2" x 17 1/8" x 1 1/2"
Courtesy of Sonnabend Gallery, New York

Jud Fine, *Watts Final Decision,* 1972

Bamboo, rubber latex, gold leaf, fiberglass, 136" x 30" x 12"
Collection Museum of Contemporary Art, Los Angeles,
Gift of Alan Shayne

Charles Arnoldi, *Untitled,* 1971

Rope and twine, 43" x 37" x 3"
Norton Simon Museum of Art,
Gift of Mr. and Mrs. Philip Gersh, 1973

Richard Jackson, *Untitled,* 1998 (replica of 1970 original)

Acrylic on canvases, painted onto wall, approximately 12' x 8'
Courtesy of the artist

Karen Carson, *Untitled,* 1971

Cotton duck and zipper, 95" x 83"
Collection of the artist

Barbara Smith, *Full Jar / Empty Jar,* 1974

Performance; artist on left
Courtesy of the artist
(not in exhibition)

John White, *Sock Performance (Diagram),* 1972

Ink on paper, 18" x 22"
Courtesy of the artist
(not in exhibition)

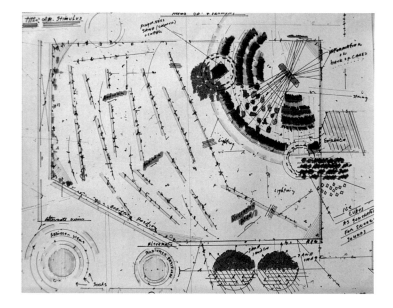

Paul McCarthy, *Hot Dog,* 1974

Video
Courtesy Patrick Painter Incorporated

John Baldessari,
How to Make a Good Movie (David and Ilene), 1973

Black and white photographs, press type to each board,
18 panels, 15" x 20 1/2" each
Courtesy Margo Leavin Gallery, Los Angeles

Allen Ruppersberg, *Seeing and Believing,* 1972

Two pieces: six color photographs, 9 1/8" x 11 5/8" each;
Two pieces: two sheets of paper 11" x 8 1/2"
Courtesy of Margo Leavin Gallery, Los Angeles

Scott Grieger, *Impersonation: Robert Irwin,* 1969

black and white photograph, 16" x 20"
Collection of Bronya and Andrew Galef and Merry Norris

William Wegman, *Before Before / On / After,* 1972

Vintage gelatin silver print, Edition 4/7, 41" x 40"
Courtesy of PaceWildensteinMacGill, Los Angeles

Merwin Belin, *Just a Friend,* 1973

Ink on paper, 18" x 24"
Courtesy of the artist

Alexis Smith, *The Scarlet Letter,* 1974

Paper collage, 12 3/4" x 99"
Courtesy of Margo Leavin Gallery, Los Angeles

Mary Corse, *Halo with Rainbow Series,* 1970

Glass microspheres in paint on canvas, 84" x 84"
Courtesy of Chac-Mool Gallery, West Hollywood

Ron Linden, *Sabbatarian,* 1974

Acrylic and graphite on canvas, 67" x 85 1/2"
Courtesy of the artist

Spandau Parks, *Studio Installation,* 1972–74

Mixed-media, variable dimensions
Courtesy of the artist

Guy Williams, *Navy Street #25,* 1975-80

Acrylic with paper and stencil on canvas, 45" x 78 1/4"
Collection of Orange County Museum of Art, Anonymous Gift

Peter Plagens, *The People's Republic of Antarctica,* 1976

Oil on canvas, 60" x 65 1/8"
Collection of Museum of Contemporary Art, San Diego,
Gift of Ruth and Murray Gribin

Connie Zehr, *Eggs,* 1972

Eggs and sand, (original dimensions 3" x 416" x 348")
Courtesy of the artist

**Influences: Selections from the
Contemporary Collection of the
Norton Simon Museum**

Alyce de Roulet Williamson Gallery,
Art Center College of Design

Marcel Duchamp,
Bottle Rack, 1963 (replica of 1914 original)

Bottle-dryer of galvanized iron, 28 3/8" x 14" diameter
Norton Simon Museum of Art, Gift of Mr. Irving Blum,
in memory of the artist, 1968

Joseph Cornell, *Hotel du Nord (Little Durer),* n.d.

Box construction, 13" x 12 1/4" x 4"
Norton Simon Museum of Art, Museum Purchase with
funds contributed by the Charles and Ellamae Storrier-Stearns
Fund and Fellows Acquistion Fund, 1967

Louise Nevelson, *Vertical Zag I,* 1968

Painted wood and formica, 80" x 29 3/8" x 4"
Norton Simon Museum of Art, Gift of the artist, 1969

John Angus Chamberlain, *Untitled,* 1962

Metal, paper, cloth on pressed board, 11 7/8" x 11 7/8" x 4 3/8"
Norton Simon Museum of Art,
Gift of Mr. and Mrs. Michael Blankfort, 1969

Robert Rauschenberg, *Cardbird II,* 1971

One of seven collaged and screen-printed cardboard wall reliefs,
Edition 26/75, Published by Gemini G.E.L., Los Angeles,
54" x 33 1/2"
Norton Simon Museum of Art, Anonymous Gift, 1972

Wayne Thiebaud, *Pastry Case,* 1964

Etching, 5" x 6 1/8"
Norton Simon Museum of Art, Gift of Mr. Paul Beckman, 1967

Claes Oldenburg,

Giant Soft Ketchup Bottle with Ketchup, 1966-67

Painted canvas filled with polyurethane foam, 100" x 52" x 40"
Norton Simon Museum of Art, Museum Purchase with
funds granted by the National Endowment for the Arts and
the Pasadena Art Alliance, 1969

Andy Warhol, *Brillo Boxes,*
1969 (replica of 1964 original)

Acrylic silkscreen on wood,
20" x 20" x 17" each
Norton Simon Museum of Art,
Gift of the artist, 1969

Tom Wesselmann, *Still Life #2,* 1962

Oil and collage on board, 48" x 48 1/8"
Norton Simon Museum of Art, Gift of Mr. Fred Heim, 1969

Joan Miró, *For Pasadena,* 1969

Color lithograph, artist's proof, 29 1/2" x 22 1/8"
Norton Simon Museum of Art, Gift of the artist, 1969

Jack Youngerman, *Red-Vermillion,* 1961

Oil on canvas, 76" x 97 3/4"
Norton Simon Museum of Art, Gift of Mr. Robert Halff, 1973

Jules Olitski, *Untitled,* 1972

Silkscreen in six colors, Edition 12/45, 26" x 35"
Norton Simon Museum of Art,
Gift of the Men's Committee, 1972

Helen Frankenthaler, *Adriatic,* 1968

Acrylic on canvas, 132 1/8" x 93"
Norton Simon Museum of Art, Gift of the artist, 1969

Kenneth Noland, *Color Temperature,* 1964

Acrylic resin on canvas, 101" x 174"
Norton Simon Museum of Art,
Gift of Mr. and Mrs. Jack Lionel Warner, 1972

Frank Stella, *Hiraqla Variation III,* 1969

Fluorescent acrylic on canvas, 120" x 240"
Norton Simon Museum of Art, Gift of the artist, 1969

Ellsworth Kelly, *White Over Blue,* 1967

Acrylic on canvas, two panels, 342" x 114"
Norton Simon Museum of Art, Gift of the artist, 1969
(illustrated horizontally)

Agnes Martin, *Leaf in the Wind,* 1963

Acrylic and graphite on canvas, 75" x 75"
Norton Simon Museum of Art,
Gift of Nicholas Wilder in memory of Jordan Hunter, 1969

Robert Morris, *Untitled,* 1969

Felt, 72" x 144"
Norton Simon Museum of Art,
Gift of the Men's Committee, 1969

Donald Judd, *Untitled,* 1966

Galvanized iron and painted aluminum, 40" x 190" x 40"
Norton Simon Museum of Art,
Gift of Mr. and Mrs. Robert A. Rowan, 1966

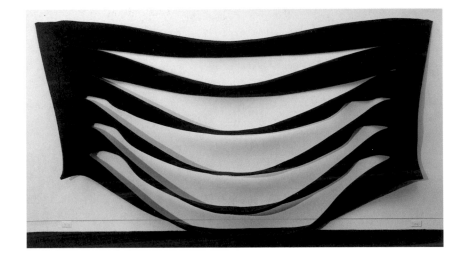

Artists' Biographies

Linda Centell

Clinton Adams was born in Glendale, California, in 1918. Following his studies at the University of California, Los Angeles, and service in the Air Force during World War II, he began teaching at the university. He was active in the California Watercolor Society for twenty years, beginning in 1946. He met Lynton Kistler in 1948, and they produced lithographic work together for many years. A solo exhibition of Adams's work was presented at the Pasadena Art Museum in 1956. In 1960 he was one of the first people to become involved in June Wayne's Tamarind Lithography Workshop. From 1970 to 1985 he directed the Tamarind Institute in Albuquerque, and he has published five books and more than one hundred essays and articles from the 1970s to present. He has had two major retrospectives at University Art Museum, University of New Mexico, Albuquerque, in 1973 and 1987. Solo exhibitions of his work have been shown in galleries and museums throughout the United States.

Venus Three Times (After Chasseriau), 1968–69
Lithograph (Tamarind impression 2524),
19 3/4" x 26"
Norton Simon Museum of Art,
Anonymous gift, 1971
(Not illustrated)

Figure in Green, 1969
Five-color lithograph
(Tamarind impression 2525), 22" x 24"
Norton Simon Museum of Art,
Anonymous gift, 1971

Peter Alexander was born in Los Angeles in 1939 and received his M.F.A. from the University of California, Los Angeles, in 1966. His work is in the permanent collection of the Norton Simon Museum, the Museum of Modern Art (MoMA) in New York, and the Los Angeles County Museum of Art. He has been commissioned to create murals for Pacific Enterprises, in 1990, and for

Santa Monica Airport, in 1989. Alexander has had numerous solo exhibitions in New York and San Francisco and at venues throughout Southern California, including the Los Angeles Municipal Art Gallery in 1983. His work was included in *New Materials and Methods* at MoMA in 1969; *Permutations: Light and Color* at the Chicago Museum of Contemporary Art in 1970; *Artists' Artists* at the Long Beach Museum in 1990; and *Light and Space* at the Orange County Museum of Art in 1995. He was a 1980 National Endowment for the Arts fellow, and his work was featured in the PBS documentary series *Artists of America* in 1971.

Mauve, 1969
Cast polyester resin, 94 3/8" x 6 5/8" x 6 3/4"
Norton Simon Museum of Art,
Gift of the Men's Committee, 1969

Terry Allen was born in 1943 in Wichita, Kansas, and raised in Lubbock, Texas. He received his B.F.A. from Chouinard Art Institute in Los Angeles in 1966 and taught at California State University, Fresno, in the 1970s. Solo exhibitions of his pop-surrealist drawings took place in 1968 at the Pasadena Art Museum and also in 1971 at the Museum of Contemporary Art in Chicago. His installation *Youth in Asia* was shown at the Newport Harbor Art Museum, Newport Beach, California, in 1992–93. In 1988–89 *Big Witness (Living in Wishes)*

traveled from San Francisco to Venice, California; Santa Barbara; Philadelphia; Madison, Wisconsin; and Tucson. His work has been included in several major assemblage exhibitions; in the 1987 Documenta in Kassel, West Germany; and in *Proof: Los Angeles Art and the Photograph, 1960–1980,* which originated at the Laguna Art Museum, Laguna Beach, California, and toured in 1992–94. Among his media are musical and theatrical performances, sculpture, painting, drawing and video, and installations, which incorporate many of these.

Brownie Bondage, 1968
Oil pastel, Scotch tape, graphite, and letterpress on paper, 28 3/4" x 23"
Collection of Jo Harvey Allen

John Altoon was born in 1925 in Los Angeles and died in 1969. He attended Otis Art Institute, Art Center School, and Chouinard Art Institute in the late 1940s. He had solo shows at the Pasadena Art Museum in 1962 and 1968 and

helped develop the artist's community around Ferus Gallery on La Cienega Boulevard in Los Angeles. His first solo exhibition was in 1951 at the Santa Barbara Museum, and a retrospective was held at the San Diego Museum of Contemporary Art in 1997. He also had solo shows at the San Francisco Museum of Art (1967); the Whitney Museum of American Art, New York (1971); and Baxter Art Gallery, California Institute of Technology, Pasadena (1984). He is best known for satirical drawings with such subject matter as advertising, religion, and sex.

Ocean Park Series #8, 1962
Oil on canvas, 81 1/2" x 84"
Norton Simon Museum of Art,
Anonymous gift, 1964

Jim's Fancy (From the Harper Series), 1966
Pen, ink, and watercolor on board, 60 1/8" x 40 1/8"
Norton Simon Museum of Art,
Gift of the artist, 1966
(Not illustrated)

Craig Antrim was born in Pasadena in 1942 and had a studio in Old Pasadena in the early 1970s. He earned his M.F.A. from Claremont Graduate School in 1970. He has taught at many schools in Southern California, including Pasadena City College; California State University (CSU), Long Beach; the University of Southern California; and Otis Parsons School of Art. His work was the subject of *Connections: Matter and Metaphor* at the Los Angeles Municipal Art Gallery in 1997, and he

has had many solo exhibitions in Southern California galleries. Group exhibitions include *Concerning the Spiritual in Art: The Eighties* at the San Francisco Art Institute in 1985; *The Spiritual in Art: Abstract Painting, 1890–1985* at the Los Angeles County Museum of Art and other venues in 1986–87; and *The Elegant, Irreverent, and Obsessive* at CSU Fullerton in 1993.

Quadruptic, C1 and C2, 1970
Oil on canvas, two panels, 12" x 16" each
Courtesy of the artist

Charles Arnoldi was born in 1946 in Dayton, Ohio. He attended Chouinard Art Institute in

1968 and within a year received the New Talent Award from the Los Angeles County Museum of Art (LACMA). His wood and twine pieces appeared in *Permutations: Light and Color* at the Chicago Museum of Contemporary Art in 1970. The Pasadena Art Museum included his work in *Fifteen Los Angeles Artists* in 1972. LACMA mounted a solo exhibition in 1984 entitled *Charles Arnoldi: Unique Prints.* He has twice received grants from the National Endowment for the Arts, and his work is in the collections of the Museum of Modern Art and the Metropolitan Museum of Art in New York and the Norton Simon Museum of Art, as well as many other institutions.

Untitled, 1971
Rope and twine, 43" x 37" x 3"
Norton Simon Museum of Art,
Gift of Mr. and Mrs. Philip Gersh, 1973

Walter Askin was born in Pasadena in 1929. He received his bachelor's and master's degrees at the University of California, Berkeley, then attend-

ed Oxford University's Ruskin School of Drawing and Fine Arts before returning to Southern California. His first solo exhibition at the Pasadena Art Museum came in 1960, and his affiliation with the museum deepened when he became a member of its board of trustees. Askin's studio has been located in Old Pasadena for decades, and he developed a close relationship with the local art community. He has been a visiting lecturer at various universities and a board member of the National Watercolor Society, Artists for Economic Action, and the Los Angeles Printmaking Society. Various articles have been written about his work, and he has published articles and been the subject of films.

The Balcony, 1965
Oil on canvas, 45" x 43"
Collection of the artist

John Baldessari was born in 1931 in National City, California. He received his M.A. from San Diego State College in 1957. He taught at California Institute of the Arts, Valencia, from 1970 until his retirement. He was awarded National Endowment for the Arts grants in 1973 and 1974–75. In 1990 a survey of his work was presented at the Museum of Contemporary Art, Los Angeles, and subsequently traveled to cities in the United States and Canada. Other solo exhibitions include a show at the Museum of Modern Art in New York in 1994 and a retrospective at Cornerhouse in Manchester, England, in 1995,

which traveled to six cities. Baldessari's work was featured in *Southern California: Attitudes 1972* at the Pasadena Art Museum. Other group exhibitions include *Art about Art* at the Whitney Museum in 1978; *American Photography in the Seventies* at the Art Institute of Chicago in 1979;

and *Avant-Garde in the Eighties* at the Los Angeles County Museum of Art in 1987. He is broadly classified as a conceptual artist who focuses on the clichés of perception and is considered a pioneer of image appropriation. He has authored several books, including *Throwing Three Balls in the Air to Get a Straight Line (Best of Thirty-six Attempts)* (1973).

How to Make a Good Movie (David and Ilene), 1973
Black-and-white photographs, presstype
Eighteen panels, 15" x 20 1/2" each
Courtesy Margo Leavin Gallery, Los Angeles

Lewis Baltz was born in Newport Beach, California, in 1945 and earned his M.F.A. from Claremont Graduate School in 1971, the year he showed his photography with that of Anthony Hernandez and Terry Wild at the Pasadena Art Museum. In 1998 his work was the subject of *Lewis Baltz: The Politics of Bacteria, Docile Bodies, Ronde de Nuit* at the Museum of Contemporary Art, Los Angeles. Other solo shows have taken place at the Corcoran Gallery of Art, Washington, D.C. (1974, 1976); the La Jolla Museum of Contemporary Art, La Jolla, California (1976); the Newport Harbor Art Museum, Newport Beach, California (1986); the Los Angeles County Museum of Art (1992); and the Louisiana Museum of Modern Art in Humlebaek, Denmark

(1995). His photographs have been featured in many group shows, including one at the Whitney Museum of American Art in New York in 1995–96, and has been shown extensively in Europe, notably in a retrospective at Fotomuseum Winterthur in Switzerland in 1993.

Tract House #4, 1971
Gelatin silver print (ed. 3/12), 5 3/4" x 8 7/8"
Norton Simon Museum of Art,
Gift of the artist, 1971

Tract House #14, 1971
Gelatin silver print (ed. 3/12), 5 7/16" x 8 7/16"
Norton Simon Museum of Art,
Gift of the artist, 1971
(Not illustrated)

Merwin Belin was born in 1951 in Phoenix, Arizona. He earned his master of fine arts degree at California State University, Long Beach, in 1975. It was during this time that he began to

create conceptual neon installations. He had a studio in Old Pasadena from 1972 to 1984. Regarding the influences that have shaped his work, Belin has said: "First, I was born on April Fool's Day. Second, I was forged in the 1960s. Third, the artist I admired most was Marcel Duchamp. And fourth, I do have some kind of humanist consciousness about what goes on in the world: the big and little dramas of life and how they're played in the media."

Just a Friend, 1973
Ink on paper, 18" x 24"
Courtesy of the artist

Larry Bell was born in Chicago in 1939 and attended Chouinard Art Institute in Los Angeles in the late 1950s. After graduation he became an active member of the Los Angeles art scene. During this time he explored the perception of space and the integration of audience and art in his two-dimensional "cube" paintings and cubic sculptures. In 1965 his glass pieces appeared in *The Responsive Eye* at the Museum of Modern Art (MoMA) in New York.

His work was shown at the Pasadena Art Museum on a number of occasions, including *Serial Imagery* (1968), *West Coast, 1949–1969* (1969), and a solo show (1972), for which he developed full-scale mirror installations. His work is in the collections of MoMA and the Solomon R. Guggenheim Museum in New York, the Los Angeles County Museum of Art, and the Norton Simon Museum of Art.

Untitled, 1969
Gray coated glass cube, 40" x 40" x 40"
Norton Simon Museum of Art,
Gift of the artist, 1969
(Not illustrated)

Untitled, 1962
Mirrored glass and chrome cube,
12 1/4" x 12 1/4" x 12 1/4"
Norton Simon Museum of Art,
Museum purchase with funds donated by the members of the 1967–68 Blum/Coplans Class, Pasadena Art Museum, 1968

Billy Al Bengston was born in Dodge City, Kansas, in 1934 and moved to Los Angeles in 1948. In 1955–56 he attended California College of Arts and Crafts in Oakland, where he studied

under Richard Diebenkorn, and then he studied at the Los Angeles County Art Institute (now Otis College of Art and Design) under Peter Voulkos. During the 1950s and 1960s his minimal paintings, influenced by the local motorcycle culture, were exhibited extensively in Southern California. By the mid-1960s he began to paint on dented aluminum, producing such works as *Holy Smoke* (1966), *Hatari* (1968), and *Paradise Canyon* (1969). In 1968 Bengston had his first solo museum shows, at the Los Angeles County Museum of Art and San Francisco Museum of Art. He participated in numerous group shows at the Pasadena Art Museum, which led up to a solo exhibition in 1969. During the 1970s he incorporated the "Dracula" iris motif into his work and experimented with various media, such as watercolor, suspended canvas, and folding screens.

Jet Inn Dracula, 1968
Two-color lithograph (Tamarind impression 2296, state II), 21 1/2" x 21 1/2"
Norton Simon Museum of Art,
Anonymous gift, 1972

Nido Dracula, 1968
Two-color lithograph (Tamarind impression 2297), 7 3/4" x 7 1/2"
Norton Simon Museum of Art,
Anonymous gift, 1969
(Not illustrated)

Dan River Dracula, 1968
Two-color lithograph (Tamarind Impression 2298), 7 3/4" x 7 1/2"
Norton Simon Museum of Art,
Anonymous gift, 1969
(Not illustrated)

Ron Benom

The Room (Part 1), 1977
Videotape
(Not illustrated)

Wallace Berman was born in Staten Island, New York, in 1926 and attended Chouinard Art Institute and Jepson Art School in 1944. He died in 1976. Berman worked in the media of photography and collage, experimenting with the Verifax machine, a predecessor of today's photocopy and facsimile machines. He had solo shows at the Ferus Gallery in 1957 and at the Los Angeles County

Museum of Art in 1968. His work was featured in *Pop Art Redefined,* which originated in London and traveled to the Pasadena Art Museum in 1969. Retrospectives of his work have been presented at Otis Art Institute in Los Angeles in 1978; the Institute of Contemporary Art in Amsterdam in 1992–93; and L.A. Louver, Venice, California, in 1997. Berman's work has appeared in many group exhibitions, including *Proof: Los Angeles Art and the Photograph, 1960–1980,* a

traveling exhibition originating at Laguna Art Museum in 1992; *Beat Culture and the New America, 1950–1965* at the Whitney Museum of American Art, New York, in 1995; and *Sunshine and Noir: Art in L.A., 1960–1997,* a traveling show originating at the Louisiana Museum of Art, Humlebaek, Denmark, in 1997.

Untitled, 1967
Verifax collage, 48" x 45 1/2"
Norton Simon Museum of Art, Gift of Mr. and Mrs. Thomas Terbell, Jr., Mr. and Mrs. Allen O. Smith, David H. Steinmetz III, Margaret T. Cunningham, and Mr. and Mrs. John S. Ferrier, 1967

William Brice was born in New York City in 1921 and attended Chouinard Art Institute in Los Angeles and the Art Students League in New York. He taught at the University of California, Los Angeles, from 1953 to 1991. His numerous solo exhibitions include shows at the Pasadena Art Museum in 1962, the Santa Barbara Museum of Art in 1967, the Los Angeles County Museum of Art in 1990, and at galleries in Southern California, San Francisco, and New York. Group exhibitions include the 1955 São Paulo Bienal; *Fifty California Artists* at the Whitney Museum of American Art, New York, in 1963; *Los Angeles Contemporary Art,* held at the Los Angeles Municipal Art Gallery and Nagoya City Museum in Japan in 1982; and *Sunshine and Shadow: Recent Painting in Southern California* at the University of Southern California in 1985. He is known for his drawings and prints as well as his paintings.

Two Figures, 1966
Color lithograph (Tamarind impression 1810), 22" x 30"
Norton Simon Museum of Art, Anonymous gift, 1968

Figures and Stream, 1966
Color lithograph (Tamarind impression 1808), 23 7/8" x 18 7/8"
Norton Simon Museum of Art, Anonymous gift, 1968
(Not illustrated)

Karen Carson was born in Corvallis, Oregon, in 1943 and received her M.F.A. from the University of California, Los Angeles, in 1971. She had a studio in Old Pasadena in the 1960s and was represented in the 1972 Pasadena Art Museum group show *Fifteen Los Angeles Artists.* She has been awarded fellowships from the Getty Trust, the National Endowment for the Arts, and the Guggenheim Foundation. In 1996 a twenty-five-year survey of her drawings and paintings was held concurrently at Otis Gallery, Los Angeles Contemporary Exhibitions, and the Santa Monica Museum of Art. Known for its wit and candor, Carson's art has been the focus of several other solo exhibitions. Group exhibitions include *The First Show: Painting and Sculpture from Eight Collections, 1940–1980* at the Museum of Contemporary Art, Los Angeles, in 1983; *The Pasadena Armory Show,* the inaugural exhibition of the Armory Center for the Arts, in 1989; *The Elegant, Irreverent, and Obsessive* at California State University, Fullerton, in 1993; and *Love in the Ruins: Art and the Inspiration of L.A.* at Long Beach Museum of Art in 1994.

Untitled, 1971
Cotton duck and zipper, 95" x 83"
Collection of the artist

Vija Celmins was born in Riga, Latvia, in 1939. She earned her M.F.A. from the University of California, Los Angeles (UCLA), in 1965. She had a solo exhibition at the Whitney Museum of American Art in New York in 1973. A survey of her work originated at the Newport Harbor Art Museum, Newport Beach, California, in 1980 and traveled to Chicago, New York, and Washington, D.C. In 1985 the Whitney Museum published *The View* by Czeslaw Milosz with four mezzotints by Celmins. Group exhibitions include *L.A.* at the San Francisco Art Institute in 1972 and *Twenty-four Young Los Angeles Artists* at the Los Angeles County Museum of Art in 1972. She has taught at California State College, Los Angeles; the University of California, Irvine; and California Institute of the Arts, Valencia. Celmins had a retrospective at the Institute of Contemporary Art, London, in 1996–97, which toured, and she was represented in *Sunshine and Noir: Art in L.A., 1960–1997,* which originated at the Louisiana Museum of Modern Art, Humlebaek, Denmark, in 1997 and traveled to UCLA at the Armand Hammer Museum of Art and Cultural Center in 1998.

Untitled, 1970
Two-color lithograph (Tamarind impression 2870), 20 1/4" x 29 1/4"
Norton Simon Museum of Art, Anonymous gift, 1972

John Chamberlain was born in Rochester, Indiana, in 1927. Beginning in the 1960s he made sculptures from crushed automobiles. More recently he has twisted and coiled steel into more organic compositions. He received Guggenheim Fellowships in 1966 and 1977. A retrospective of his work was held in 1986 at the Museum of Contemporary Art, Los Angeles. In 1996 *John Chamberlain: Current Work and Fond Memories,*

Sculptures, and Photographs, 1967–1995 was shown in Amsterdam and Wolfsburg, Germany. Other solo exhibitions have been shown at the Solomon R. Guggenheim Museum in New York in 1971, the 1994 São Paulo Bienal, the Pace Wildenstein and Leo Castelli Galleries in New York, and other venues. Group exhibitions include *Constructing American Identity* at the Whitney Museum of American Art, New York (1991); *American Art of the Twentieth Century* in Berlin and London (1993); and *The Tradition of the New* (1994) and *Abstraction in the Twentieth Century: Total Risk, Freedom, Discipline* (1996), both at the Guggenheim.

Untitled, 1962
Metal, paper, cloth on pressed board,
11 7/8" x 11 7/8" x 4 3/8"
Norton Simon Museum of Art,
Gift of Mr. and Mrs. Michael Blankfort, 1969

Judy Chicago (née Gerowitz) was born in Chicago in 1939. She received her M.A. at the University of California, Los Angeles, and had a studio in downtown Pasadena from 1965 to 1970.

She collaborated with her then-husband, Lloyd Hamrol, and Barbara Smith on *Raymond Rose Ritual Environment* on New Year's Eve in 1972. Her geometric sculptures were shown in a solo exhibition at the Pasadena Art Museum in 1969, and she also did *Multi-Color Atmosphere,* a fireworks performance at the museum's entrance. As a teacher at Fresno State College in the early 1970s, she pioneered feminist

art education. Then, at California Institute of the Arts, she and Miriam Shapiro established the Feminist Art Program, which created *Womanhouse,* the first art installation with an openly feminist point of view. Between 1974 and 1979, with the assistance of hundreds of volunteers, she created her most famous work, *The Dinner Party.* That monumental work, as well as others by the artist, was featured in *Sexual Politics: Judy Chicago's "Dinner Party" in Feminist Art History* at UCLA at the Armand Hammer Museum of Art and Cultural Center in 1996. Chicago is the author of several books, including *Through the Flower: My Struggle as a Woman Artist* (1993).

Pasadena Lifesavers Red Series #5, 1970
Sprayed acrylic lacquer on acrylic, 60" x 60"
Collection of the Grinstein Family

Max Cole was born in Kansas in 1937 and received her bachelor's degree from Fort Hays State University in Hays, Kansas, and her M.F.A. in painting from the University of Arizona. From 1969 to 1976 her studio was located in Old Pasadena. Recent one-person exhibitions have taken place at galleries in Cologne, Stuttgart,

and Frankfurt in 1997; at the Museum of Modern Art in Ottendorf, Germany, in 1998; and in San Francisco, Zurich, New York, and Düsseldorf. Group exhibitions featuring her work have included *Visions of Inner Space: Gestural Painting in Modern American Art* at the Wight Art Gallery, University of California, Los Angeles, in 1987–88 and *Mind and Matter: New American Abstraction,* which toured museums in Southeast Asia in 1989.

Cole's horizontal line paintings reference landscape and the transmission of energy, revealing the limitless variety within restricted order while affirming life's imperfections.

Meridian I, 1977
Oil and ink on canvas, 52 1/4" x 62 1/4"
Museum of Contemporary Art, San Diego,
Gift of Ruth and Murray Gribin

Bruce Conner was born in McPherson, Kansas, in 1933 and received a B.F.A. from the University of Nebraska, Lincoln, in 1956. He has worked in many media and was a seminal force in assemblage and collage. Since 1957 he has also been an independent filmmaker. He was awarded a National Endowment for the Arts grant in 1973 and a Guggenheim Fellowship in 1975. Among his solo exhibitions are a 1974 traveling retrospective that originated at the DeYoung Museum in San Francisco, a traveling exhibition of photograms in 1985, and a 1992 show at the San Francisco Museum of Modern Art. Group exhibitions include *California Painting and Sculpture: The Modern Era,* a traveling exhibition originating at the San Francisco Museum of Modern Art in 1976, and *Different Drummers* at the Hirshhorn Museum and Sculpture Garden, Washington, D.C., in 1988. His works are in many museum collections, including that of the Norton Simon Museum of Art.

Couch, 1963
Cloth-covered couch with wood frame, figure, cloth, and paint, 32" x 70 3/4" x 27"
Norton Simon Museum of Art, Museum purchase with funds donated by Mr. David H. Steinmetz III and an anonymous foundation, 1969

Ron Cooper was born in Venice, California, in 1943. He studied at Chouinard Art Institute in the mid-1960s and is known as an environmental artist and photographer. In 1968 he was commissioned by the Library of Congress to create *Floating Volume Atmosphere.* He received a National Endowment for the Arts grant in 1970. In 1972 he had a solo show at the Pasadena Art Museum and was included in Documenta 5 in Kassel, West Germany. He was honored with purchase awards from the Los Angeles County Museum of Art in 1968 and the Solomon R. Guggenheim Museum, New York, in 1971. His work is also in the collection of the Whitney Museum of American Art, New York. He was a director of the Los Angeles Institute of Contemporary Art for many years. Cooper was a pioneer of the light and space movement and has always been concerned with the process of perception and the prevalence of deception. Since 1974 his work has reflected his interest in the problem-solving abilities of the camera.

Corner Piece, 1970
Polyester resin, fiberglass, pigment,
144" x 12" x 1/16"
Collection of the artist

Joseph Cornell, a self-taught artist, was born in Nyack, New York, in 1903 and died in 1972. He was associated with the New York surrealists in the 1930s and 1940s. He had his first solo museum exhibitions in 1967 at the Pasadena Art Museum and the Solomon R. Guggenheim Museum in New York. His work was the focus of solo shows at the National Collection of Fine Arts, Smithsonian Institution, Washington, D.C., in 1973 and at the Museum of Modern Art (MoMA), New York, in 1980. He was also represented in *Fantastic Art, Dada, and Surrealism* in 1936 and *The Art of Assemblage* in 1961, both at MoMA; *Painting and Sculpture of a Decade, 1954–1964,* at the Tate Gallery, London, in 1984; *Transformation in Sculpture* at the Guggenheim in 1985; and *Seven Artists in Depth: The Creative Process* at the San Francisco Museum of Modern Art in 1986. Cornell's three-dimensional collages, especially his boxes, were forerunners of assemblage.

Hotel du Nord (Little Dürer), n.d.
Box construction, 13" x 12 1/4" x 4"
Norton Simon Museum of Art, Museum purchase with funds contributed by the Charles and Ellamae Storrier-Stearns Fund and Fellows Acquisition Fund, 1967

Mary Corse was born in Berkeley in 1945. She earned her B.F.A. from Chouinard Art Institute in 1966. The Museum of Contemporary Art in Chicago showed her work in *Permutations: Light and Color* in 1970, and the Los Angeles County Museum of Art exhibited her atmospheric paintings in *Twenty-four Los Angeles Artists* in 1971. In 1972 she participated in the Pasadena Art Museum's show *Fifteen Los Angeles Artists,* along with Lloyd Hamrol, Tom Wudl, and others. Her work was included in *Decade: Los Angeles Painting of the Seventies* at Art Center College of Design in Pasadena in 1981 and *Images of an Era* at the Museum of Contemporary Art in Los Angeles in 1994. She has had many solo exhibitions in New York and Los Angeles, and her work is in the permanent collections of major museums. Her paintings reveal a concern for the effects of light on the surface of black-and-white canvases, and she has been associated with the light and space artists.

Halo with Rainbow Series, 1970
Glass microspheres in paint on canvas, 84" x 84"
Courtesy of Chac-Mool Gallery, West Hollywood

Ron Davis was born in Santa Monica, California, in 1937 and attended San Francisco Art Institute from 1960 to 1964. In 1963 he began to paint in a hard-edge, geometric, optical style. His first solo exhibition was at Nicholas Wilder Gallery in Los Angeles in 1965. In 1968 he received a National Endowment for the Arts grant. He had a studio in Old Pasadena and a solo exhibition at the Pasadena Art Museum in 1971, around the time he was using colored polyester resins and fiberglass. In 1974 he had a solo show at Gemini G.E.L., and his work was included in Documenta 4 in Kassel in 1968 and the Venice Biennale in 1972. A retrospective of his work was held in Oakland in 1976. Group exhibitions include *California Painting and Sculpture* at the San Francisco Museum of Art in 1977 and *Art in Los Angeles: Seventeen Artists in the Sixties* at the Los Angeles County Museum of Art in 1981.

Wyoming Slab, 1974
Vinyl-acrylic copolymer and dry pigment on canvas, 108" x 174"
Norton Simon Art Foundation,
Gift of Mr. Norton Simon

Jay DeFeo was born in Hanover, New Hampshire, in 1929 and died in 1989. She earned her M.A. in painting from the University of California, Berkeley, in 1951. Her monumental assemblage, *The Rose,* created between 1954 and 1968, was included in a solo show at the Pasadena Art Museum in 1969 and was also included in a retrospective shown at Moore College of Art and Design, Philadelphia, and at the University Art Museum, Berkeley, in 1996–97. A survey of four decades of her work was shown at John Berggruen Gallery in San Francisco in 1996. Group exhibitions include *Late Fifties at Ferus* at the Los Angeles County Museum of Art in 1968; *Forty Years of California Assemblage* at the Wight Art Gallery, University of California, Los Angeles, in 1989; *Beat Culture and the New America, 1950–1965* at the Whitney Museum of American Art, New York, in 1995; and *The San Francisco School of Abstract Expressionism,* which traveled from the Laguna Art Museum, Laguna Beach, California, to the San Francisco Museum of Modern Art in 1996. She received National Endowment for the Arts grants in 1973 and 1984.

Daphne, 1958
Oil, pencil, and charcoal on paper mounted on canvas, 125 3/4" x 47 3/4"
Norton Simon Museum of Art,
Gift of Mr. Sam Francis, 1965

Laddie John Dill was born in Long Beach, California, in 1943. He received his B.F.A. at Chouinard Art Institute in Los Angeles in 1968.

In 1971 he was represented in *Twenty-four Young Los Angeles Artists* at the Los Angeles County Museum of Art and also displayed his neon sculpture in a solo show at the Pasadena Art Museum. Recently he has shown his work at Chac-Mool Gallery and the Municipal Art Gallery in Los Angeles. He has received two artist's fellowships from the National Endowment for the Arts, a Guggenheim Fellowship, and a grant from the California Arts Council. His work is in the collections of the Corcoran Gallery of Art and the Smithsonian Institution, Washington, D.C.; the Art Institute of Chicago; and the Los Angeles County Museum of Art.

The Glass Sentence, 1971
Argon and mercury, 5/8" x 72"
Collection of Ariel Dill

Marcel Duchamp was born in Blainville, France, in 1887. He died in 1968. His painting *Nude Descending a Staircase* created an uproar when it was included in the *International Exhibition of Modern Art,* commonly known as the Armory Show, in New York in 1913. He had solo exhibitions at the Solomon R. Guggenheim Museum in New York and several major European museums before his first major retrospective, *By or of Marcel Duchamp or Rrose Selavy,* was held at the Pasadena Art Museum in 1963. He was represented in two important shows on Dada and surrealism at the Museum of Modern Art in New York: *Fantastic Art, Dada, and Surrealism* in 1936 and

Dada, Surrealism, and Their Heritage in 1968. The greatest concentration of his works is the Arensberg Collection at the Philadelphia Museum of Art, a collection assembled in Los Angeles. In his later years Duchamp devoted much of his time to chess, and a famous photograph was taken of him playing chess with a nude woman at the Pasadena Art Museum.

Bottle Rack, 1963 (replica of 1914 original)
Galvanized iron, h: 28 3/8"; diam: 14"
Norton Simon Museum of Art, Gift of Mr. Irving Blum, in memory of the artist, 1968

Poster for the Pasadena Retrospective: At the Pasadena Art Museum…Wanted, $2,000 Reward…by or of Marcel Duchamp or Rrose Selvay…a Retrospective Exhibition…October 8 to November 3, 1963, 1963
Color offset lithograph, 34 1/2" x 27 1/4"
Norton Simon Museum of Art, Museum archives

L.H.O.O.Q. or La Joconde, 1964
(replica of 1919 original)
Colored reproduction, heightened with pencil and white gouache (ed. 6/35; Arturo Schwartz edition), 11 3/4" x 7 7/8"
Norton Simon Museum of Art,
Gift of Virginia Dwan, 1969

Untitled (hand and cigar), c. 1967
Lithograph (ed. 90/100), 27 1/4" x 19"
Norton Simon Museum of Art, Gift of Mr. John Coplans in homage to Mr. Walter Hopps, 1969
(Not illustrated)

Tom Eatherton was born in Los Angeles in 1934 and received his B.A. from the University of California, Los Angeles, in 1957. He was a founding committee member of the Santa Monica Museum of Art. In the late 1960s he created light

and space environments in his Santa Monica studio. In 1970, at Pomona College in Claremont, he created an environment with a low light level on two curving walls, and in 1972, in *New Directions*

at the Pasadena Art Museum, he installed a low-light-level environment with a curving panel of overhead blue light. His cylinder of vertical straight lines of blue light was seen at the University of California, Irvine, in 1974. In 1981 he presented a computer-driven display at ARCO Center for the Visual Arts, which was analogous to a large abstract painting that paints itself for six months without repeating. His work has been shown at Otis Art Institute, and in 1990 he created a permanent mile-long installation of steel, glass, and fiber-optic panels in a subway tunnel for the Los Angeles County Transportation Commission.

Move, 1972
Iris print of installation of steel, plastic, cloth and incandescent light (print by Duganne Atelier),
20" x 20" x 60 ft. (installation size)
Courtesy of the artist

Leonard Edmondson was born in 1916 in Sacramento and earned his M.A. from the University of California, Berkeley. His first exhibition was at Felix Landau Gallery in 1950, and he had shows at the Pasadena Art Museum in 1953 and at the San Francisco Museum of Art in 1956 and 1967. His work has been in many group exhibitions, including a show at the Museum of Modern Art, New York (1952); the São Paulo Bienal (1955), and *Painting and Sculpture in California: The Modern Era* at the San Francisco Museum of Modern Art (1976). Edmondson has

taught at Pasadena City College; Los Angeles State College and California State University, Los Angeles; and Otis Art Institute. He has won many purchase prizes, including six at the Pasadena Art Museum, and a Guggenheim Fellowship.

Botanical Garden #2, 1960
Serigraph, 13" x 26"
Norton Simon Museum of Art,
Gift of Mr. and Mrs. Oscar Salzer, 1960
(Not illustrated)

Cabal, n.d.
Color etching (ed. 5/50), 15 1/2" x 19 1/4"
Norton Simon Museum of Art, Museum purchase, Third Biennial Print Exhibition Purchase Award, 1961

Jim Eller was an active Los Angeles artist in the early 1960s. He attended Chouinard Art Institute and further refined his skills with courses in anatomy and technical illustration at other colleges. His imaginative readymades and assemblage pieces were presented in *Painting and Sculpture in California: The Modern Era* at the San Francisco

Museum of Modern Art in 1976 and in *Beat Culture and the New America, 1950–1965* at the Whitney Museum of American Art in 1995 as well as at the Smithsonian Institution, Washington, D.C.

Red Container, 1994 (replica of 1962 original)
Anodized aluminum and glass, 30" x 15" x 15"
Courtesy of the artist

Claire Falkenstein was born in Coos Bay, Oregon, in 1908 and received her B.A. from the University of California, Berkeley, in 1930. Her first major solo exhibition after her studies with Alexander Archipenko at Mills College in Oakland was held at the San Francisco Museum of Art in 1940, and her works have been exhibited at the Musée du Louvre, Paris; the Tate Gallery, London; the Whitney Museum of American Art, New York; the Art Institute of Chicago; the Solomon R. Guggenheim Museum, New York; and the Smithsonian Institution, Washington, D.C. Her Fusions of 1954 resulted in the use of metal and

glass for the renowned gates at the entrance to the Guggenheim Museum in Venice, Italy. She was commissioned to do the *Tide Pool Fountain* in San Francisco in 1983. A retrospective of her work was held in 1984 at Jack Rutberg Fine Art in Los Angeles, and she had a solo exhibition at the Museum of Contemporary Art in Los Angeles in 1989. Her work is in the permanent collection of the Norton Simon Museum.

Regal Box, n.d.
Glass and wire in metal box, 12" x 9" x 3 1/2"
Norton Simon Museum of Art, Gift of Mr. and Mrs. Frederick R. Weisman, 1967

Jud Fine received his M.F.A. from Cornell University, Ithaca, New York, in 1970. His early work was featured in *Southern California: Attitudes 1972* at the Pasadena Art Museum. Group shows include *Seven Sculptors: New Involvement with Materials* at the Institute of Contemporary Art, Boston, in 1974; *Downtown Los Angeles,* which

originated at Madison Art Center, Wisconsin, in 1981 and traveled to eight other institutions; and *California Sculpture* in 1984, which traveled from the Fisher Gallery, University of Southern California (USC), to venues in France, Germany, England, and Norway. His work was the subject of a 1988 solo exhibition at the San Diego Museum of Contemporary Art. Fine has been awarded several grants from the National Endowment for the Arts and numerous sculpture commissions, including one for Exposition Park in Los Angeles. He has been a professor at USC since 1988.

Watts Final Decision, 1972
Bamboo, latex rubber, gold leaf, fiberglass,
136" x 30" x 12"
Museum of Contemporary Art, Los Angeles,
Gift of Alan Shayne

Robbert Flick was born in Amersfoort, Holland, in 1939. He earned his M.F.A. from the University of California, Los Angeles, in 1971. His work was featured in the Pasadena Art Museum's exhibition *California Photography 1970.* Flick has received more than ten grants and fellowships. His recent tenure as a Getty Scholar resulted in an exhibition at the Getty Research Institute, *Along Alameda.* In 1982 he had a solo exhibition at the Municipal Art

Gallery in Los Angeles. Group shows include *Pasadena: A Photographic Exploration* at the Armory Center for the Arts in 1993; *PLAN: Photography Los Angeles Now* at the Los Angeles County Museum of Art in 1995; and *Photographers on Location: Landscapes and Cityscapes from the National Museum of American Art,* a 1997 traveling exhibition. His work is in numerous museum collections.

Untitled, Excerpt, L.A. Book of the Dead, 1969–70
Gelatin silver print, 11" x 14 1/2"
Norton Simon Museum of Art,
Museum purchase, 1971

Untitled, Excerpt, L.A. Book of the Dead, 1969–70
Gelatin silver print, 11" x 14 1/2"
Norton Simon Museum of Art,
Museum purchase, 1971
(Not illustrated)

Llyn Foulkes
was born in 1934 in Yakima, Washington. In 1957 he moved to Los Angeles, where he attended Chouinard Art Institute. His work was shown at the Pasadena Art

Museum in several group exhibitions—including *Director's Choice* (1962), *United States of America, V Paris Bienniale* (1967), and *West Coast Art: Permanent Collection* (1972)—and in a solo exhibition, *An Introduction to the Paintings of Llyn Foulkes,* in 1962. He was represented in *Five Los Angeles Artists* at the Los Angeles County Museum of Art in 1965. In 1974 a survey of his work since 1959 was presented at the Newport Harbor Art Museum, Newport Beach, California, and in 1995–96 the Laguna Art Museum, Laguna Beach, California, presented *Llyn Foulkes: Between a Rock*

and a Hard Place. His work is in the collections of the Los Angeles County Museum of Art, the Museum of Contemporary Art in Los Angeles, and the Museum of Modern Art in New York.

In Memory of St. Vincent School, 1960
Oil, charred wood, plasticized ashes on blackboard, chair, 66" x 72 1/4" x 12 1/2"
Norton Simon Museum of Art,
Gift of Dr. and Mrs. Harry Zlotnick, 1969

Post Card, 1964
Oil on canvas, 63 1/2" x 62 1/4"
Norton Simon Museum of Art,
Anonymous gift, 1966
(Not illustrated)

Sam Francis was born in San Mateo, California, in 1923 and died in 1994. While a tuberculosis patient at hospitals in Denver and San Francisco, he began painting, studying privately with David Park from 1944 to 1947 and at the Artists' Colony in Carmel in 1947. His first four solo shows were in Paris, New York, London, and Bern in the 1950s. He had solo shows at the Pasadena Art Museum in 1959, 1964, and 1967. His first exhibition there traveled to the San Francisco Museum of Art and the Seattle Art Museum. In 1970 he had an individual exhibition at the Los Angeles County Museum of Art, and his 1972 retrospective was shown in New York, Washington, D.C., Dallas, and Oakland. Group exhibitions include *Twelve Americans* at the Museum of Modern Art, New York, in 1956;

American Painting: Abstract Expressionism and After at the San Francisco Museum of Art in 1987, and international exhibitions. His monotypes and paintings are characterized by their glowing colors, which he has described as light on fire.

Pasadena Suite, 1965
Four-color lithograph on Rives BFK paper
(ed. 2/100), 23 1/2" x 15 3/4"
Printed at Gemini G.E.L. by Kenneth Tyler
Norton Simon Museum of Art,
Gift of the Pasadena Art Alliance, 1966

Pasadena Suite, 1965
Three-color lithograph on Rives BFK paper
(ed. 2/100), 13 3/4" x 10 3/4"
Printed at Joseph Press by Joe Zirker
Norton Simon Museum of Art,
Gift of the Pasadena Art Alliance, 1966
(Not illustrated)

Helen Frankenthaler was born in New York City in 1928. She attended the Art Students League and studied privately with Hans Hofmann. She has been a painting instructor at Yale and Princeton Universities and Hunter College, among other institutions. In 1959 she won first prize at the Paris Bienniel. Retrospectives of her work have been shown in New York at the Whitney Museum of American Art in 1969 and at the Museum of Modern Art in 1989 (traveled to Los Angeles). Group shows of note include *Abstract Expressionists and Imagists* in 1961 at the Solomon R. Guggenheim Museum, New York, and *After Matisse* in 1986 at the Queens Museum, Flushing, New York, which traveled to several major cities. Frankenthaler insists on our awareness of paint as a fluid, spreading medium, and her use of the staining technique influenced painters such as Morris Louis, Kenneth Noland, and Jules Olitski.

Adriatic, 1968
Acrylic on canvas, 132 1/8" x 93"
Norton Simon Museum of Art,
Gift of the artist, 1969

Joe Goode was born in Oklahoma City in 1937 and studied at Chouinard Art Institute. Following his participation in the controversial exhibition *War Babies* at Huysman Gallery in

1961, he became an active member of the Los Angeles art scene. The Pasadena Art Museum featured his work a year later in *New Painting of Common Objects.* Goode's painting-installations, such as *Milk Bottle Painting (Blue),* were representative of pop art, but they were unique not only in their three-dimensionality but also in their quiet, reflective nature. In 1968 he had a two-person exhibition with Ed Ruscha at the Balboa Pavilion Gallery in Balboa, California, and in 1997 his work was featured in a solo exhibition at the Orange County Museum of Art in Newport Beach, California. He is a two-time recipient of National Endowment for the Arts grants, and his work is in the collections of the Museum of Modern Art, New York; the Museum of Contemporary Art, Los Angeles; and the Smithsonian Institution, Washington, D.C.

Torn Cloud Painting, 1971
Oil on canvas, 61 1/2" x 60"
Collection of the artist

Robert Graham was born in Mexico City in 1938 and studied at San Jose State College and San Francisco Art Institute. The Los Angeles County Museum of Art presented solo exhibitions of his sculpture in 1978, 1981, and 1988. Group exhibitions include the 1966 Whitney Biennial, *L.A. Eight: Painting and Sculpture 76* at the Los Angeles County Museum of Art in 1976, and

California Sculpture, 1959–80 at the San Francisco Museum of Modern Art in 1986. His work is in many public collections, including the Museum of Modern Art in New York, the Museum of Contemporary Art in Los Angeles, and the Norton Simon

Museum of Art. Graham has received commissions for various architectural projects and civic monuments in Los Angeles, including the Olympic Gateway at the Los Angeles Memorial Coliseum (1984), the Music Center, and the Bunker Hill Steps. His bronze figures have been described as metaphors for the human spirit.

A Most Incredible Plot, Part II, 1964
Etching (artist's proof), 20" x 12"
Norton Simon Museum of Art,
Museum purchase, Fourth Biennial Print
Exhibition Purchase Award, 1964
(Not illustrated)

Untitled (Shower), 1966
Assorted plastics, sand, pigmented beeswax,
metal foils, paint, wood, h: 14"; diam: 36 3/8"
Norton Simon Museum of Art,
Museum purchase, 1966

Scott Grieger

was born in Biloxi, Mississippi, in 1946. He attended Chouinard Art Institute and earned a B.F.A. from California State University, Northridge, in 1971. In 1998 he had a solo exhibition at Patricia Faure Gallery in Santa Monica and was included in *LA Current: The Canvas Is Paper* at UCLA at the Armand Hammer Museum of Art and Cultural Center. In 1995 he was represented in the touring exhibition *It's Only Rock and Roll: Rock and Roll Currents in Contemporary Art.* In 1984 he received a midcareer grant from the National Endowment for the Arts. His work was included in *Twenty-four Young Los Angeles Artists* at the Los Angeles County Museum of Art in 1971 and *Information* at the Museum of Modern Art, New York, in 1970. Grieger had a studio in Old Pasadena in the 1960s. His work is in public collections in Los Angeles and New York.

Impersonation: Robert Irwin, 1969
Black-and-white photograph, 16" x 20"
Collection of Bronya and Andrew Galef and Merry Norris

Impersonation: Robert Rauschenberg, 1969
Black-and-white photograph, 16" x 20"
Collection of Bronya and Andrew Galef and Merry Norris
(Not illustrated)

Susan Grieger
Bodies: More than 19,476 Combinations, n.d.
Artist's book, offset lithography, 9 1/2" x 6 1/2"
Collection of Hal and Mary Ann Glicksman, Santa Monica
(Not illustrated)

Lloyd Hamrol

was born in 1937 in San Francisco. He earned his B.F.A. and M.F.A. at the University of California, Los Angeles, after which he taught at the California Institute for the Arts in Valencia. The Los Angeles County Museum of Art showed his early sculpture in *American Sculpture in the Sixties* in 1966. He worked in Pasadena between 1965 and 1972 with his then-wife, Judy Chicago. When Hamrol moved to Pasadena, he became an active member of the local art community. He donated an installation to the Pasadena Art Museum in 1972, following his participation in *Fifteen Los Angeles Artists.* Along with Chicago and Barbara Smith, he created a performance piece on New Year's Eve 1972, *Raymond Rose Ritual Environment,* which utilized film projections on buildings and fog machines.

Untitled Situational Construction, 1972
Electrical sleeving supported by nylon mono-filament, 76" x 132" x 96" (approx.)
Courtesy of the artist

Robert Heinecken

was born in Denver in 1931 and earned his M.A. in 1960 from the University of California, Los Angeles, where he taught for the next thirty years. He received a Guggenheim Fellowship and several National Endowment for the Arts grants. An early solo show of his photographs was held at the Long Beach Museum of Art in 1968, followed by an exhibition at the Pasadena Art Museum in 1972. A retrospective of his work was held in 1989 at Pace/MacGill Gallery in New York. Group exhibitions include *Photography and Art: Interactions*

since 1946 at the Los Angeles County Museum of Art in 1987 and *Proof: Los Angeles Art and the Photograph, 1960–1980* at Laguna Art Museum, Laguna Beach, California, in 1993, both of which toured. His photographs have been seen at the Whitney Museum of American Art and the Museum of Modern Art, both in New York, and in major museums in Europe. In early works he created

sculpture out of photographs in a visual-verbal interplay reminiscent of some of the issues of Marcel Duchamp and the cubists.

Fourteen or Fifteen Buffalo Ladies #3–II, 1969
Photolithography and chalk, 17 7/8" x 14 1/8"
Norton Simon Museum of Art,
Gift of Mrs. Barbara St. Martin, 1969

George Herms

was born in Woodland, California, in 1935. He attended the University of California, Berkeley, and his first solo show was in 1960 at Semina Gallery in Larkspur, California. His work is in the permanent collection of the Norton Simon Museum of Art. He believes in the vitality of the found object, which he recontextualizes as art. *The Prometheus Archives: A Retrospective of the Works of George Herms* was held at the Newport Harbor Art Museum, Newport Beach, California, in 1979. His work was included in *Forty Years of California Assemblage* at the Wight Art Gallery, University of California, Los Angeles, in 1989 and in *Beat Culture and the New America, 1950–1965* at the Whitney Museum of American Art in 1995 (traveled to Paris). Most recently his work was included in *Sunshine and Noir: Art*

in *L.A., 1960–1997,* which originated at the Louisiana Museum of Modern Art in Humlebaek, Denmark, in 1997 and traveled to UCLA at the Armand Hammer Museum of Art and Cultural Center in Los Angeles in 1998.

The Librarian, 1960
Wood box, papers, brass bell, books, and painted stool, 57" x 63" x 21"
Norton Simon Museum of Art,
Gift of Molly Barnes, 1969

For the Corner Pass, 1962
Collage of paper, foil, ink, and feathers on paper, 16" x 8 1/2"
Norton Simon Museum of Art,
Gift of the artist, 1963
(Not illustrated)

Anthony Hernandez was born in Los Angeles in 1947. His photography captured the essence of the 1970s through urban portraiture. The Pasadena Art Museum exhibited his work in two traveling group exhibitions: *California Photographers* (1970) and *The Crowded Vacancy* (1971). He has had solo shows at the Corcoran Gallery of Art in Washington, D.C., and the

California Museum of Photography in Riverside. More recently, his photographs were the subject of a solo exhibition at Dan Bernier Gallery in Los Angeles. Group exhibitions include *Scene of the Crime* at UCLA at the Armand Hammer Museum of Art and Cultural Center, Los Angeles, in 1997 and shows at the San Francisco Museum of Modern Art, the Santa Barbara Museum of Art, and the National

Museum of American Art, Smithsonian Institution, Washington, D.C. His photographs are in the collections of the Whitney Museum of American Art in New York, the Los Angeles County Museum of Art, and the Fonds National d'Art Contemporain in Paris.

Untitled, 1970
Gelatin silver print, 14 1/2" x 11 1/2"
Norton Simon Museum of Art,
Gift of the artist, 1970

Untitled, 1970
Gelatin silver print, 14 1/2" x 11 1/2"
Norton Simon Museum of Art,
Gift of the artist, 1970
(Not illustrated)

Patrick Hogan was born in Los Angeles in 1947 and died in 1988. He completed a painting degree at California State University, Northridge, and received the New Talent Award from the Los Angeles County Museum of Art in 1970. His first solo show was at Orlando Gallery, Encino, California, in 1969. He subsequently had solo shows at the San Francisco Museum of Modern Art and the Santa Barbara Museum of Art, both in 1974; the Newport Harbor Art Museum, Newport Beach, California, in 1980; the Solomon R. Guggenheim Museum, New York, in 1981; and P.S. 1 in New York in 1982. Early group exhibitions include *Nine Artists* at the University of California, Irvine, and *A Decade of California Color* at Pace Gallery in New York, both in 1970. In 1971 he was included in *Twenty-four Young Los Angeles Artists* at LACMA, and the following year his work appeared in *L.A. '72* at Sidney Janis Gallery in New York and *Southern California: Attitudes 1972* at the Pasadena Art Museum. He received three National Endowment for the Arts grants and a Guggenheim Fellowship.

Untitled, 1978
Rope and acrylic on wood panel, 30 1/4" x 60 1/2"
Collection of Museum of Contemporary Art, Los Angeles, Gift of Michael Hogan from the Patrick Hogan Estate

Dennis Hopper was born in Dodge City, Kansas, in 1936. In the 1960s he chronicled, in black-and-white photography, the creative and political cultures of Los Angeles. In 1969 he cowrote, directed, and starred in *Easy Rider,* which portrayed the counterculture. He is the author of *Abstract Reality* (1998) and coauthor, with Michael McClure and Walter Hopps, of *Dennis Hopper: Out of the Sixties* (1986). His photographs have been included in many group exhibitions, including *Beat Culture and the New America, 1950–1965* at the Whitney Museum of American Art, New York, in 1995; and *Hall of Mirrors: Art and Cinema since 1945* at the Museum of Contemporary Art, Los Angeles, in 1996; and *Sunshine and Noir: Art in L.A., 1960–1997,* which originated at the Louisiana Museum of Art, Humlebaek, Denmark, in 1997 and traveled to UCLA at the Armand Hammer Museum of Art and Cultural Center in 1998. He has had many solo exhibitions, including *Bomb Drop,* an installation at the Pasadena Art Museum in 1968.

Bomb Drop, 1967–68
Neon sculpture, 48" x 132" x 48"
Courtesy of the artist (Not in exhibition)

Robert Irwin was born in Long Beach, California, in 1928 and attended Chouinard Art Institute and Otis Art Institute. He has been an instructor at the University of California campuses at Irvine and Los Angeles, and at Chouinard. He

had solo exhibitions at the Pasadena Art Museum in 1960 and 1968. Individual exhibitions include several at Ferus Gallery in Los Angeles in the 1960s and retrospectives at the Whitney Museum of American Art in New York in 1977, the San Francisco Museum of Modern Art in 1985, and the Museum of Contemporary Art, Los Angeles, in 1986. In 1985 he was awarded a MacArthur Foundation Fellowship. Irwin's is an art of perception, and since the 1970s he has created many installations, including *Scrim Wall* at the Portland Center for the Visual Arts; *Tumbling Glass Planes* at Lake Placid, New York; *Light to Solid* at the Louisiana Museum of Modern Art in Humlebaek, Denmark; and *9 Spaces / 9 Trees* in Seattle's Arts Commission Plaza. Most recently, he designed a garden for the new Getty Center in Los Angeles.

Untitled, 1962–63
Oil on canvas, 83 1/8" x 83 1/4"
Norton Simon Museum of Art,
Gift of the artist, 1969
(Not illustrated)

Untitled, 1967–68
Acrylic lacquer on formed acrylic plastic, diam: 54"
Norton Simon Museum of Art, Museum Purchase, Fellows Acquisition Fund, 1969

Richard Jackson was born in Sacramento in 1939 and attended Sacramento State College from 1958 to 1961. He had a studio in Old Pasadena, at the house owned by Walter Hopps.

His work was included in *Fifteen Los Angeles Artists* at the Pasadena Art Museum in 1972. Other group exhibitions include *Photography into Sculpture* at the Museum of Modern Art in New York in 1970; *Twenty-four Young Los Angeles Artists* at the Los Angeles County Museum of Art (LACMA) in 1971; *The Museum as Site: Sixteen Projects* at LACMA in 1981; *One of a Kind: Contemporary Serial Imagery* at the Los Angeles Municipal Art Gallery in 1988; and *Helter Skelter: L.A. Art in the 1990s* at the Museum of Contemporary Art, Los Angeles, in 1992. Solo exhibitions include *Big Confusing Ideas* at the Santa Monica Museum of Art, Santa Monica, California, in 1992 and *Richard Jackson: Installations, 1970–1988* at the Menil Collection, Houston, in 1988.

Untitled, 1998 (replica of 1970 original)
Acrylic on canvases, painted onto wall,
96" x 144" (approx.)
Courtesy of the artist

Ynez Johnston was born in 1920 and earned her M.F.A. from the University of California, Berkeley, in 1947. She has received many awards, including a Guggenheim Memorial Fellowship and grants from the National Endowment for the Arts. She had a solo exhibition at the Pasadena Art Museum in 1955 and a two-person exhibition there with the poet John Berry in 1962. Prior to that she had a solo exhibition in 1943 at the San Francisco Museum of Art, which also mounted a retrospective of her graphic works in

1967. Retrospectives of her work were held at Mount San Antonio College in California in 1974 and at the Johnson Museum of Art, Cornell University, in 1978. A world traveler, Johnston has had traveling shows in Japan and Spain and has exhibited in São Paulo, Rome, Florence, and Vancouver. Her fanciful dreamscapes are inspired by Mayan stone carvings; cave paintings; and Asian, Indian, and Persian art.

The Black Pagoda IX, 1966
Four-color lithograph (Tamarind impression 1657), 30" x 22"
Norton Simon Museum of Art,
Anonymous gift, 1968

Donald Judd was born in Excelsior Springs, Missouri, in 1928 and earned his M.A. from Columbia University in New York in 1962. He died in 1994. He received National Endowment for the Arts grants in 1967 and 1976 and a Guggenheim Fellowship in 1968. Retrospectives of his work were held at the Whitney Museum of American Art in New York in 1968 and at the Pasadena Art Museum in 1971. He has had solo shows in major European and American museums. Group exhibitions include *American Sculpture of the 1960s* at the Los Angeles County Museum of Art in 1967; *American Art, 1950 to Present* at the Whitney Museum in 1978; Documenta 5 in Kassel, West Germany, in 1982; and *Abstraction in the Twentieth Century: Total Risk, Freedom, Discipline* at the Solomon R. Guggenheim Museum in New York in 1996. Best known as a minimalist sculptor, Judd created works

composed of rows of precise, geometric metal boxes or similar forms, which he called specific objects. He was also a critic and theorist, and his complete writings were published in 1975 and 1987.

Untitled, 1966
Galvanized iron, painted aluminum, 40" x 190" x 40"
Norton Simon Museum of Art,
Gift of Mr. and Mrs. Robert A. Rowan, 1966

Allan Kaprow was born in Atlantic City, New Jersey, in 1927. He attended New York University, Columbia University, and the New School for Social Research. *Self-Service: A Happening by Allan Kaprow* took place at the Pasadena Art Museum in 1966, followed by *Fluids* in 1967, the year he also had a retrospective at that institution.
In 1987 his work was in *Berlinart, 1961–1987* at Museum of Modern Art in New York and the San Francisco Museum of Modern Art, and in 1998 he was represented in *Out of Actions: Between Performance and the Object, 1949–1979* at the Museum of Contemporary Art, Los Angeles. He is the author of *Assemblage, Environments, and Happenings* (1966) and *Sweet Wall Testimonials* (1976). He has taught at several universities and at California Institute of the Arts, Valencia, in the mid-1970s. Kaprow's early performance art took the form of happenings, or spectaculars, defined as spontaneous, plotless theatrical events. Rather than providing answers, his works foreground possibilities.

Allan Kaprow at his Pasadena Art Museum exhibition, 1967
Installation photograph
Courtesy Norton Simon Museum of Art

Craig Kauffman was born 1932 in Los Angeles and earned his M.F.A. from the University of California, Los Angeles, in 1956. He has taught at the University of California campuses at Irvine and Berkeley and at the School of Visual Arts in New York. He began his exhibition career at Ferus Gallery in Los Angeles. His Plexiglas sculp- tures were shown at the Pasadena Art Museum on multiple occasions, including *United States of America, V Paris Bienniale* in 1967, *West Coast, 1945–1969* in 1969, and a solo exhibition in 1970. Since then major solo shows have included *Craig Kauffman: A Comprehensive Exhibition, 1957–1980,* at the La Jolla Museum of Contemporary Art, La Jolla, California, in 1981, and *Craig Kauffman: Wall Reliefs, 1967–69* at the Whitney Museum of American Art, New York, in 1987. In 1976 he was represented in *Seventy-five Years of California Art* at the San Francisco Museum of Modern Art and *Recent Los Angeles Work* at the Museum of Modern Art, New York.

Untitled (Washboard Series), 1965
Acrylic on vacuum-formed Plexiglas,
76 5/8" x 38 1/2" x 4 7/8"
Norton Simon Museum of Art,
Gift of Vivian C. Kauffman, 1970

Untitled, 1968
Sprayed acrylic lacquer on vacuum formed Plexiglas, 19" x 55 1/2" x 10"
Norton Simon Museum of Art, Museum Purchase, Fellows of the Acquisition Fund, 1968
(Not illustrated)

Ellsworth Kelly was born in Newburgh, New York, in 1923 and attended the Boston Museum School, Pratt Institute in Brooklyn, and the Académie des Beaux-Arts in Paris. He had solo shows in New York, London, Paris, and West Germany before his shows in 1965 and 1966 at Ferus Gallery in Los Angeles. His 1973 retrospective at the Museum of Modern Art (MoMA) in New York traveled to the Pasadena Art Museum the following year. He had solo shows at MoMA again in 1978 and 1990. His 1979 solo exhibition originating at the Stedelijk Museum, Amsterdam, toured Europe. He has also had solo exhibitions at the Metropolitan Museum of Art (1979) and the Whitney Museum of American Art in New York (1982) and at the Fort Worth Museum of Modern Art in Texas (1987). His work was included in the touring show *Post Painterly Abstraction,* which originated at the Los Angeles County Museum of Art in 1964; *New York Painting and Sculpture, 1940–1970* at the Metropolitan Museum in 1969; and many other exhibitions. His canvases are a direct study in shape, color, and proportion.

White over Blue, 1967
Acrylic on canvas, two panels, 342" x 114" overall
Norton Simon Museum of Art, Gift of the artist, 1969

Blue / Red-Orange, 1973
Color lithograph (ed. 44/55), 36 1/4" x 36 1/2"
Published by Gemini G.E.L., Los Angeles
Norton Simon Museum of Art,
Gift of the Men's Committee, 1974
(Not illustrated)

Edward Kienholz was born in Fairfield, Washington, in 1927. From 1957 to 1963 he directed Ferus Gallery with Walter Hopps. In 1961 his work was shown in a solo exhibition at the Pasadena Art Museum and in *Art of Assemblage* at the Museum of Modern Art (MoMA) in New York. He was represented in *Fifty California Artists* at the Whitney Museum in New York in 1962; in *Dada, Surrealism, and Their Heritage* at MoMA in 1968; and in Documenta 5 in Kassel, West Germany, in 1972. Known for his life-size sculptural tableaux, he was awarded a Guggenheim grant in 1975. A retrospective of his work (which from 1972 until his death in 1994 was made in

collaboration with his wife, Nancy Reddin Kienholz) opened in 1996 at the Whitney Museum of American Art, New York, and traveled to the Museum of Contemporary Art, Los Angeles. Solo shows have also been presented at the Walker Art Center in Minneapolis, the Contemporary Arts Museum in Houston, and the San Francisco Museum of Modern Art. Kienholz's works are in many major museum collections.

The Secret House of Eddie Critch, 1961
Drop-front wood veneered writing desk containing plastic doll parts, leather, wood, chicken wire, and animal fur, 24" x 32 1/4" x 13"
Norton Simon Museum of Art,
Gift of Mrs. Sadye J. Moss, 1966

Gary Krueger was born in Des Moines in 1945 and earned his B.F.A. at Chouinard Art Institute in 1967. He has been a commercial freelance photographer since 1968. His work was included in *Southern California: Attitudes 1972* at the Pasadena Art Museum. His photographs were included in *LAXSIX* at Mount Saint Mary's College in Los Angeles in 1976 and in *Attitudes:*

Photography in the 1970s at the Santa Barbara Museum of Art in 1979. In 1973 his images appeared in *Coast Magazine* in the article "California Eyes: How Four Top Photographers See the West." In 1975 he was featured in the California issue of *Photo,* a French magazine, and in *Communication Arts,* in an article titled "Exhibit: Gary Krueger." In 1977 his work was included in a *Los Angeles Times* article, "Six Photographers in Search of the City of Angels."

Untitled, 1970
Gelatin silver print, 8" x 10"
Courtesy of the artist

Untitled, 1971
Gelatin silver print, 8" x 10"
Courtesy of the artist
(Not illustrated)

Rico Lebrun was born in Naples, Italy, in 1900 and was educated there at the National Technical Institute. He died in 1964. Since the 1940s his art has been shown extensively in major museums. In 1957 he became director of the Jepson Art Institute in Los Angeles, where he had been teaching since 1947. In 1963 his work was exhibited in *Twentieth-Century Master Drawings,* a traveling show originating at the Solomon R. Guggenheim Museum in New York. His Holocaust

Paintings were exhibited at the Jewish Museum in New York in 1997. The Montgomery Gallery, Pomona College, in Claremont, California, presented *Rico Lebrun: The Genesis Mural* in 1998. Group exhibitions in Southern California include *Drawings and Illustrations by Southern California Artists Before 1950* at Laguna Art Museum, Laguna Beach, California, in 1982; *Turning the Tide: Early Los Angeles Modernists, 1920–1956,* a traveling show originating at the Santa Barbara Museum of Art in 1990; and *Figuratively Speaking* at the Santa Barbara Museum in 1996.

Flood Figures, 1961
Lithograph (ed. 1/8), 18 1/2" x 36 1/2"
Norton Simon Museum of Art, Museum purchase, Third Biennial Print Exhibition Purchase Award, 1961

Roy Lichtenstein was born in New York City in 1923. He earned his M.F.A. in 1949 from Ohio State University, Columbus, and studied at the Art Students League in New York. He taught at Ohio State University, New York State College of Education in Oswego, and Rutgers University, New Brunswick, New Jersey, all before his first museum retrospective, at the Pasadena Art Museum in 1967, which traveled to the Tate Gallery in London and

the Stedelijk Museum in Amsterdam in 1968. In 1969 there was a retrospective at the Solomon R. Guggenheim Museum in New York. A survey exhibition opened at the Saint Louis Art Museum in 1981 and traveled to the Whitney Museum of American Art in New York. Group exhibitions featuring his work have included *New Painting of*

Common Objects at the Pasadena Art Museum in 1962; *New York Painting and Sculpture, 1940–70* at the Metropolitan Museum of Art, New York, in 1969; *Art and Technology* at the Los Angeles County Museum of Art in 1971; and *Painterly Visions, 1940–84* at the Solomon R. Guggenheim Museum in New York in 1985.

Big Modern Painting (For Expo '67), 1967
Oil and magna on canvas, three panels,
120" x 360" overall
Norton Simon Museum of Art,
Gift of the artist and Mr. Leo Castelli, 1967

Ron Linden earned his M.F.A. from the University of Illinois, Urbana, in 1966. He had many one-person exhibitions at Ovsey Gallery, Los Angeles, in the 1980s and has also had solo

shows at the Downtown Gallery, Los Angeles, and the Los Angeles Institute of Contemporary Art. He had a studio in Old Pasadena in the early 1970s, and he was awarded a National Endowment for the Arts grant in 1978. His work was included in *Decade: L.A. Painting in the Seventies* at Art Center College of Design in Pasadena in 1981 and in *Critical Perspectives* at P.S. 1 in New York in 1982. More recently his work has been in group exhibitions at the Laguna Art Museum (1992, 1998), Laguna Beach, California, and at many galleries in Southern California. Linden's monumental layered abstract paintings from the early 1970s combined sections of words and geometric forms.

Sabbatarian, 1974
Acrylic and graphite on canvas, 67" x 85 1/2"
Courtesy of the artist

Peter Lodato was born in Los Angeles in 1946. He received his B.A. at California State University, Northridge, and studied art history there at the graduate level. He set up a studio in Pasadena in 1970 and remained in the city for eleven years. In 1972, for the exhibition *Twenty-four Los Angeles Artists* at the Los Angeles County Museum of Art, he created an untitled installation

that juxtaposed light with shadow and closed space with open doorways. He began his teaching career in 1975 at the University of California, Irvine, and went on to the California Institute for the Arts in Valencia. During the later part of the decade his spatial experiments were taken to the realm of color field painting. This period was reflected in the 1981 exhibition *Decade: Los Angeles Painting in the Seventies* at Art Center College of Design in Pasadena.

Rouge, 1972–81
Enamel and plaster on wall, 120" x 72"
Courtesy of the artist

Agnes Martin was born in Saskatchewan, Canada, in 1912 and attended Columbia University in New York and the University of New Mexico, Albuquerque, where she also taught. She had solo shows in the late 1950s in New York and Los Angeles before her 1973 retrospective, which

originated at the Institute of Contemporary Arts at the University of Pennsylvania, Philadelphia, and traveled to the Pasadena Art Museum. In the 1990s she was represented in a Venice Biennale and had traveling retrospectives at the Stedelijk Museum in Amsterdam and the Whitney Museum of American Art in New York. Group exhibitions include *Aspects of Post-War Painting in America* in 1976 and *Singular Dimensions in Painting* in 1993, both at the Solomon R. Guggenheim Museum in New York, and *The Reductive Object: A Survey of the Minimalist Aesthetic in the 1960s* at the Institute of Contemporary Art in Boston in 1979. She is often linked to hard-edge abstractionists but is also aligned with the first generation of abstract expressionists.

Leaf in the Wind, 1963
Acrylic and graphite on canvas, 75" x 75"
Norton Simon Museum of Art, Gift of Nicholas Wilder in memory of Jordan Hunter, 1969

John Mason was born in Madrid, Nebraska, in 1927 and attended Otis Art Institute and Chouinard Art Institute, both in Los Angeles. He had a solo show at the Pasadena Art Museum in 1960, and his retrospective there in 1974 was the final exhibition before the museum's closing. Recent solo shows have taken place in Chicago, New York, San Francisco, and Los Angeles. Early group exhibitions include *Fifty California Artists* at the Whitney Museum of American Art in New York in 1962; *American Sculpture of the Sixties* at

the Los Angeles County Museum of Art in 1967; and *California Painting and Sculpture: The Modern*

Era at the San Francisco Museum of Modern Art in 1976. More recently his work was included in *The First Show: Painting and Sculpture from Eight Collections, 1940–1980* at the Museum of Contemporary Art in Los Angeles in 1983.

Firebrick Sculpture—Pasadena, 1974
Firebricks, 85 1/2" x 200" x 200"
Norton Simon Museum of Art,
Gift of the artist, 1973

Cynthia Maughan was born in Bell, California, in 1949, and earned her M.A. from California State University, Long Beach, in 1974. She had a studio in Old Pasadena in the 1970s. In 1975 she was awarded a National Endowment for the Arts grant, and that year her videos were included in a Long Beach Museum of Art group exhibition that traveled to San Francisco and New York. Her work was included in Documenta 6 in Kassel, West Germany, in 1977. A retrospective of her work from 1974 to 1984 was held at the Long Beach Museum of Art in 1985. Maughan has been a guest lecturer at several art institutions in California and created performances at such venues as the Anti-Club in Los Angeles in the mid-1980s. Her writing was published in *Criss Cross, Double Cross,* a collection of poetry and short stories, in 1976. The *LAICA Journal* published an excerpt from her novel *Hummingbirds* in 1978. Among her early videos are *Spider-Cat-Water* and *This Is a Message of Infinite Patience from the Mind of the Universe.*

Compilation, 1974–75
Video, 56 min.
Long Beach Museum of Art
(Not illustrated)

Paul McCarthy was born in Salt Lake City, Utah, in 1945. He earned his M.F.A. from the University of Southern California in Los Angeles in 1973. He had a studio in Old Pasadena in the 1970s. Since 1984 he has taught new forms, performance, video, installation, and performance art history at the University of California, Los Angeles. He also curates exhibitions and has been guest editor for magazines. Solo exhibitions include *Painter* in the projects room at the Museum of Modern Art, New York, in 1995; *Pinocchio Pipenose Householddilemma Tour,* which traveled in Europe and the United States in 1995; and *Photographs, Performance Photographs, and Video,*

1969–1983 in 1998 at Patrick Painter in Santa Monica, California. Group shows in Los Angeles in 1998 include *Sunshine and Noir: Art in L.A., 1960–1997,* at UCLA at the Armand Hammer Museum of Art and Cultural Center and *Out of Actions: Between Performance and the Object, 1949–1979* at the Museum of Contemporary Art. His work was included in the Venice Biennale in 1993.

Hot Dog, 1974
Video
Courtesy Patrick Painter, Incorporated

John McCracken was born in 1934 in Berkeley. He studied at the California College of Arts and Crafts, then taught on the East Coast in the 1960s and 1970s. In the mid-1960s he became known for sculptures consisting of monochromatic planks of wood or fiberglass covered with bright, reflective colors, which leaned against the wall in a fusion of painting and sculpture. His

first major group exhibition was *Arts of San Francisco* at the San Francisco Museum of Art in 1965. Afterward he returned to the West Coast to teach at the University of California, Irvine, and later taught at the University of California, Los Angeles. His work appeared at the Pasadena Art Museum in *United States of America, V Paris Bienniale* in 1967 (traveling from the

Musée d'Art Moderne in Paris). In 1969 he returned to New York and exhibited in *Art of the Real* at the Museum of Modern Art. He was awarded a National Endowment for the Arts grant in 1968. In 1989 his art was featured in *Geometric Abstraction and Minimalism in America* at the Solomon R. Guggenheim Museum in New York.

Blue Post and Lintel I, 1965
Plywood, fiberglass and lacquer, 102" x 32" x 17"
Norton Simon Museum of Art, Gift of Mr. and Mrs. Frederick R. Weisman, 1967

John McLaughlin was born in Sharon, Massachusetts, in 1898 and died in 1976. A self-taught artist, he studied Eastern philosophy, art, and languages. By 1948 he had developed his geometric style independent of other painters of

the "hard-edge" school, which was first linked with the Los Angeles area in 1959. McLaughlin participated in a group exhibition at the Pasadena Art Museum before his 1963 retrospective there. Prior to that, this "old master of

California modernism" was included in *Contemporary Painting in the United States* at the Los Angeles County Museum of History, Science, and Art in 1951 and in the São Paulo Bienal in 1955. In 1977 McLaughlin was represented in the *Los Angeles Hard-Edge Exhibition* at the Los Angeles County Museum of Art. His work has been the subject of exhibitions at the Corcoran Art Gallery, Washington, D.C. (1968); the La Jolla Museum of Contemporary Art, La Jolla, California (1973); and numerous other institutions in the United States and Europe. In 1996 *John McLaughlin: Western Modernism, Eastern Thought* was presented at the Laguna Art Museum, Laguna Beach, California. He received a National Endowment for the Arts grant in 1967.

Untitled, 1963
Lithograph (ed. 1/20), 18 1/2" x 21 3/4"
Norton Simon Museum of Art,
Museum purchase, 1965

Jerry McMillan was born in Oklahoma City in 1936 and educated at Chouinard Art Institute in Los Angeles from 1958 to 1960. Solo exhibitions of his work have taken place at the Pasadena Art Museum in 1966, the San Francisco Museum of Art in 1971, the Newport Harbor Art Museum in 1972, and Margo Leavin Gallery in 1977. Group exhibitions include *Lost and Found in California: Four Decades of Assemblage Art* at G. Ray Hawkins Gallery in Los Angeles in 1987; *The Pasadena Armory Show* at the Armory Center for the Arts in 1989; *Joe Goode, Jerry McMillan, Edward Ruscha* at Oklahoma City

Art Museum in 1989 (traveled to Orlando, Florida); and *Photographing the L.A. Art Scene, 1955–1975* at Craig Krull Gallery in Santa Monica. He was awarded a National Endowment for the Arts grant in 1984–85. His drawings, prints, and photographs have been the subject of many exhibitions since 1960 and have helped define the early contemporary art scene in Southern California.

Tree Bag, 1966
Photographic construction,
13 3/4" x 5 7/8" x 3 1/4"
Norton Simon Museum of Art,
Museum purchase with funds donated by
Mr. Frederick G. Runyon, 1967

Joan Miró was born in Barcelona in 1893 and attended schools there and in Paris, where in the 1920s he was associated with the surrealists. His first solo show was in 1918 in Barcelona, and his paintings, engravings, and sculpture have been shown extensively in galleries and major museums throughout his career and since his death in 1983. He designed sets with Max Ernst in 1926 for Diaghilev's ballet *Romeo and Juliet.* He won the 1954 grand prize for graphics at the Venice Biennale and in 1958 was awarded a Guggenheim Fellowship. His work has appeared in numerous group exhibitions, including *Modern Art in the West* at the Metropolitan Museum in Tokyo in 1983 and *Painterly Visions, 1940–84* at the Solomon R. Guggenheim Museum in New York in 1985. Zoomorphic and anthropomorphic forms and emblems recur throughout his work. Miró transformed aspects of cubism into surrealist art and is considered one of the masters of the surrealist movement.

For Pasadena, 1969
Color lithograph (artist's proof),
29 1/2" x 22 1/8"
Norton Simon Museum of Art,
Gift of the artist, 1969

Robert Morris was born in Kansas City, Missouri, in 1931 and received his M.A. in 1962 from Hunter College in New York. He was awarded a Guggenheim Fellowship in 1969. In 1970 alone his work was the subject of solo exhibitions at Irving Blum Gallery in Los Angeles, the Detroit Institute of Arts, the Whitney Museum of American Art in New York, and the Stedelijk Museum in Amsterdam. The following year he had a solo show at the Tate Gallery in London. Group exhibitions include *Information* at the Museum of Modern Art in New York in 1970, *Art about Art* at the Whitney Museum in 1978, the 1980 Venice Biennale, and *Avant-Garde in the Eighties* at the Los Angeles County Museum of Art in 1987. *Robert Morris: The Mind/Body Problem* opened at the Solomon R. Guggenheim Museum in New York in 1994 and traveled to the Centre Georges Pompidou in Paris in 1995. His works are in the permanent collection of the Norton Simon Museum of Art, among other institutions. Morris's "anti-form" felt pieces are said to counter the universal shapes of minimalist works. Another well-known work, *Box with the Sound of Its Own Making,* employs recorded sounds to add history to the viewer's experience.

Untitled, 1969
Felt, 72" x 144"
Norton Simon Museum of Art,
Gift of the Men's Committee, 1969

Edward Moses was born in Long Beach, California, in 1926 and received his M.A. from the University of California, Los Angeles, in 1958. Immediately after graduation he became affiliated with the Ferus Gallery and its artists, including John Altoon, Billy Al Bengston, and Robert Irwin. For the next ten years he moved between San Francisco, New York, and Europe while painting in a loose abstract expressionist style. Following his return to Southern California, his work was shown at the Los Angeles County Museum of Art in *The Late Fifties at Ferus* in 1968 and at the Pasadena Art Museum in *West Coast, 1945–1969* in 1969. He taught at the University of California campuses at Los Angeles and Irvine. Moses's experiments with paint and canvas were influenced by indigenous cultures, employing earth-tone stains on raw canvas and repetitive line resembling basket weaving. He is said to have anticipated the trend in pattern painting. A major retrospective of his works was held at the Museum of Contemporary Art in Los Angeles in 1996.

Rafe, 1959
Oil and collage on canvas, 72 1/8" x 64 1/4"
Norton Simon Museum of Art,
Gift of Mr. Harris Newmark, 1968

Lee Mullican was born in Chickasha, Oklahoma, in 1919 and educated in Oklahoma, Texas, and Missouri, at the Kansas City Art Institute. With Wolfgang Paalen and Gordon Onslow Ford, he formed the Dynaton movement in San Francisco in 1951. He was awarded a Guggenheim Fellowship in painting

in 1959–60. The Pasadena Art Museum mounted a retrospective of his work in 1961. Other solo shows have taken place at the University of California, Los Angeles, Art Gallery in 1969; the Santa Barbara Museum of Art in 1973 and 1976; the Los Angeles Municipal Art Gallery in 1980; and, more recently, the Pavilion at the Botanical Garden in Munich, Germany. Group shows include *New Objects* in 1961 and *West Coast, 1945–1969* in 1969, both at the Pasadena Art Museum; *Dynaton Revisited* at the Los Angeles County Museum of Art in 1977; and *Pacific Dreams: Currents of Surrealism and Fantasy in California Art, 1934–1957* at UCLA at the Armand Hammer Museum of Art and Cultural Center in Los Angeles in 1995.

The Wave, 1969
Lithograph (Tamarind impression 2824), 30" x 22"
Norton Simon Museum of Art,
Anonymous gift, 1972

Clark Murray was born in 1937 in Flagstaff, Arizona. He attended San Francisco State College and San Francisco Art Institute in the early 1960s; moved to New York for a year to paint; then moved to Pasadena, where he exhibited at the Nick Wilder Gallery until 1969. The six months he then spent in India influenced his art. In 1970 he moved to London and began making sculpture. Murray then moved to New York, where he continued to make sculpture until 1980, when he returned to painting and sailed across the Atlantic Ocean to the Mediterranean Sea. He spent five summers sailing that area. He now paints in New York City and Rhinebeck, New York.

Untitled, 1966
Acrylic on canvas, 46 1/2" x 33 1/2"
Collection of Hal and Mary Ann Glicksman

Bruce Nauman was born in 1941 in Fort Wayne, Indiana. He received his M.F.A. from the University of California, Davis, in 1966, during which time he began to create his first performance pieces, films, and raw, organically shaped fiberglass sculptures. The San Francisco Museum of Art featured his sculpture in *New Directions: The Tenth SECA Show* in 1966. He received an NEA grant in 1968. The following year he moved to Pasadena and taught at the University of California, Irvine. At this point he discontinued the fiberglass sculpture and focused on performance art and installation documented on video. The Los Angeles County Museum of Art (LACMA) mounted a major retrospective in 1972, *Bruce Nauman: Work from 1965 to 1972.* He also had solo shows at the Museum of Modern Art in New York in 1985 and at the Walker Art Center, Minneapolis, in 1994. Group exhibitions include *Avant-Garde in the Eighties* at LACMA in 1987 and *The Broadening of the Concept of Reality in the Art of the 60s and 70s* in West Germany.

Raw War, 1970
Neon tubing with clear-glass tubing suspension frame (ed. 6), 6 1/2" x 17 1/8" x 1 1/2"
Courtesy of Sonnabend Gallery, New York

Louise Nevelson was born in Kiev, Russia, in 1900 and died in 1988. She studied at the Art Students League and with Hans Hofmann in Munich in the early 1930s. She was an assistant to Diego Rivera in Mexico City in the early 1930s, and received Tamarind Fellowships in 1963 and 1967. Her first solo exhibition was at Karl Nierendorf Gallery in New York, and she had solo shows at the Whitney Museum of American Art in New York in 1967 and 1970, at the San Francisco Museum of Modern Art in 1974, the Solomon R. Guggenheim Museum in New York in 1986, and the Centre Georges Pompidou in Paris in 1988.

Group exhibitions include *Tamarind: Homage to Lithography* in 1969 at the Museum of Modern Art, New York; *American Art at Mid-Century* in 1973 at the National Gallery of Art, Washington, D.C.; *Two Hundred Years of American Sculpture* in 1976 at the Whitney Museum; and *Transformation in Sculpture* in 1985 at the Guggenheim Museum.

Vertical Zag I, 1969
Painted wood and Formica, 80" x 29 3/8" x 4"
Norton Simon Museum of Art,
Gift of the artist, 1969

Kenneth Noland was born in Asheville, North Carolina, in 1924. He attended Black Mountain College in the 1940s and the Institute of Contemporary Arts in Washington, D.C., in 1949 and 1950, where he also taught. A traveling retrospective of his work originated at the Solomon R. Guggenheim Museum in New York in 1977. He was represented in *Three American Painters* in 1965 and *Painting in New York, 1944–69* in 1969–70, both at the Pasadena Art Museum. Other group exhibitions include *Post-Painterly Abstraction* at the Los Angeles County Museum of Art in 1964, which toured, and *New York Painting and Sculpture, 1940–1970* at the Metropolitan Museum of Art in New York in 1969. His highly formal, minimal work consists of concentric circles, horizontal bands, and later plaids, which explore color relationships.

Color Temperature, 1964
Acrylic resin on canvas, 101" x 174"
Norton Simon Museum of Art, Gift of
Mr. and Mrs. Jack Lionel Warner, 1972

Claes Oldenburg was born in Stockholm, Sweden, in 1929. He earned a B.A. in 1950 from Yale University and attended the Art Institute of Chicago. In 1961 he opened *The Store,* an installation of his giant soft sculptures, in his studio. A solo show of his drawings and prints, which originated at the Museum of Modern Art (MoMA) in New York in 1969, toured Europe. In 1970 he had a solo show at the Tate Gallery in London. *Object into Monument,* his solo show originating at the Pasadena Art Museum, toured the United States and Japan in 1971–72. In 1978 he had a solo show at the Whitney Museum of American Art in New York. *Claes Oldenburg: An Anthology* opened at the National Gallery of Art, Washington, D.C., in 1995 and traveled to other museums in the United States and Europe. Group exhibitions include *Painting and Sculpture of a Decade, 1954–*

1964 at the Tate Gallery in 1964; *American Pop Art* at the Whitney Museum in 1974; *Drawing Now* at MoMA in 1976; *Printed Art: A View of Two Decades* at MoMA in 1980; and *American Painting: Abstract Expressionism and After* at the San Francisco Museum of Modern Art in 1987.

Giant Soft Ketchup Bottle with Ketchup, 1966–67
Painted canvas filled with polyurethane foam
100" x 52" x 40"
Norton Simon Museum of Art, Museum purchase with funds granted by the National Endowment for the Arts and the Pasadena Art Alliance, 1969

Notes I–XII, 1968
Twelve color lithographs (ed. 21/100),
22 5/8" x 15 3/4" each
Published by Gemini G.E.L., Los Angeles

Norton Simon Museum of Art,
Gift of Mr. and Mrs. Lou Faibish, 1969
(Not illustrated)

Jules Olitski was born in Snovsk, Russia, in 1922 and earned his M.A. from New York University in 1954. He had solo shows at the

Pasadena Art Museum in 1967 and 1973. Olitski is one of the leading American post-painterly abstractionists and is best known for his color-field paintings of the late 1960s. In the early 1960s he had solo shows in Florence, Rome, Milan, and New York. His retrospective in 1967 originated at the Corcoran Gallery of Art in Washington, D.C., and toured the United States. He had solo shows at the Metropolitan Museum of Art in New York in 1969 and at the Hirshhorn Museum and Sculpture Garden in Washington, D.C., in 1977. He has been represented in many group exhibitions, including *New York Painting and Sculpture, 1940–1970* at the Metropolitan Museum of Art in 1969 and *The Great Decade of American Abstraction: Modernist Art, 1960–70* at the Museum of Fine Arts in Houston in 1974.

Untitled, 1970
Silkscreen in six colors (ed. 12/45), 26" x 35"
Norton Simon Museum of Art,
Gift of the Men's Committee, 1972

Michael Olodort was born in Los Angeles in 1942. His first solo show was at Rolf Nelson Gallery in Los Angeles. Group exhibitions include *Director's Choice,* organized by Walter Hopps for the Pasadena Art Museum in 1964; *Sterling Holloway's Especially for Children* at the Los Angeles County Museum of Art in 1966; a group exhibition at the San Francisco Museum of Art in 1968; and *Southern California: Attitudes 1972* at the Pasadena Art Museum.

Dancing Stone Hangar, c. 1966
Pastel on paper, 19" x 25"
Collection of the Grinstein Family

John Outterbridge was born in Greenville, North Carolina, in 1933 and attended Agricultural and Technical University in Greensboro, North Carolina, and the American Academy of Art in Chicago in the late 1950s. He was awarded a Fulbright Fellowship and an honorary doctorate from Otis College of Art and Design in Los Angeles in 1994, the year of his retrospective at the California Afro-American Museum in Los Angeles. His work was in the 1994 São Paulo Bienal and the 1995 Africus Biennale in Johannesburg, South Africa. In 1995 his assemblages of recycled materials were shown in *Altars* at the Armory Center for the Arts. His work has also been included in exhibitions at the Long Beach Museum of Art, La Jolla Museum of Art, the Los Angeles County Museum of Art, and other Southern California museums, and at the Studio Museum in Harlem. He was an art instructor and fine arts installer at the Pasadena Art Museum from 1967 to 1972, was artistic director of Communicative Arts Academy in Compton, California, from 1969 to 1975, and was director of Watts Towers Arts Center in Los Angeles from 1975 to 1992.

From Another Point of View, Containment Series, c. 1968
Stainless steel and wood, 84" x 26"
Collection of Joan and Fred Nicholas

Spandau Parks was born in 1944 in Peoria, Illinois, and earned his B.F.A. from Bradley University there in 1969. He earned his M.F.A. from the University of Southern California in

1971. He maintained a studio in Pasadena from 1972 through 1979. His works of that period often took the form of mixed-media installations. He had solo exhibitions at Newspace Gallery in Los Angeles in 1975 and at Taka Ishii Gallery in Los Angeles in 1998. His oil paintings were in a group exhibition at Los Angeles Contemporary Exhibitions in Hollywood in 1994.

Studio Installation, 1972–74
Mixed media, variable dimensions
Courtesy of the artist

Helen Pashgian was born in Pasadena. She received her B.A. at Pomona College in Claremont, California; attended Columbia University; and earned her M.A. from Boston University. She was deeply connected to the Pasadena art scene, and the Pasadena Art Museum exhibited her work in 1965. In 1970 she was artist-in-residence at the California Institute of Technology. Solo exhibi-

tions of her work have been held in galleries in New York, San Francisco, and Southern California. Group exhibitions featuring her work have taken place at the Museum of Contemporary Art, Chicago, in 1970; the Los Angeles County Museum of Art in 1977 and 1978; the Los Angeles Municipal Gallery in 1980; the Laguna Art Museum, Laguna Beach, California, in 1984 and 1986; and Madison Art Center in Wisconsin in 1994. She has been mentioned in *Who's Who in American Art* (1993) and *Who's Who in America* (1996), and her work is in the collections of the Los Angeles County Museum of Art, the Santa Barbara Museum of Art, and the Laguna Art Museum.

Untitled, 1969
Multicolored cast resin sphere, diam: 10"
Courtesy of the artist

Richard Pettibone was born in Alhambra, California, in 1938. He earned his M.F.A. from Otis College of Art and Design in 1962. His early work was exhibited at Ferus Gallery and was featured in *New Painting of Common Objects* at the Pasadena Art Museum in 1962. A survey of his work from 1961 to 1981 took place at Los Angeles Valley College in Van Nuys in 1981, and he has also had solo exhibitions in galleries in New York, San Francisco, and Los Angeles. Group exhibitions include *Painting and Sculpture in California: The Modern Era* at the San Francisco Museum of Modern Art in 1976; *Art about Art* at the Whitney Museum of American Art in New

York in 1978; *2 X Immortal: Elvis + Marilyn,* a traveling show that originated at the Institute of Contemporary Art in Boston in 1994; and *Degrees of Abstraction: From Morris Louis to Mapplethorpe* at the Museum of Fine Arts, Boston, in 1995. He is the recipient of grants from the Pollock-Krasner Foundation and the National Endowment for the Arts.

Roy Lichtenstein: Picasso's Woman with Flowered Hat, 1963, 1970
Silkscreen on canvas (artist's proof),
7 5/8" x 6 1/4"
Norton Simon Museum of Art,
Gift of the Men's Committee, 1970

Peter Plagens was born in Dayton, Ohio, in 1941 and earned his B.F.A. at the University of Southern California (USC) in 1962 and his M.F.A. from Syracuse University in 1964. He had a studio in Old Pasadena from 1970 to 1978. His work was included in the group exhibition *Market Street Program* at the Pasadena Art Museum in 1973. He has had solo exhibitions at the Hirshhorn Museum and Sculpture Garden in Washington, D.C., in 1977; at the Nancy Hoffman Gallery in New York from 1975 to 1992; and at Akron Art Museum in Ohio in 1996. Group exhibitions include *Sunshine and Shadow: Recent Painting in Southern California* at USC in 1985 and *Slow Art: Painting in New York Now* at P.S. 1 in New York in 1992. He is the art critic for *Newsweek* and author of *Sunshine Muse: Contemporary Art on the West Coast* (1974). From 1969 to 1976 he was a contributing and associate editor of *Artforum.* Plagens has received several fellowships and has taught at the University of North Carolina, Chapel Hill; USC; California State University, Northridge; and the University of Texas.

The People's Republic of Antarctica, 1976
Oil on canvas, 60" x 65 1/8"
Museum of Contemporary Art, San Diego,
Gift of Ruth and Murray Gribin

Kenneth Price was born in Los Angeles in 1935 and received his B.F.A. at the University of Southern California in 1956. He then studied at the Los Angeles County Art Institute and became involved in Ferus Gallery. He earned his M.F.A. at New York State College of Ceramics at Alfred University in 1959. Upon his return to Los Angeles he exhibited his ceramics at the Pasadena Art Museum in *New American Sculpture* in 1964. His work also appeared in the Los Angeles County Museum of Art's 1967 exhibition *American Sculpture of the Sixties.* In 1979 his art was included in the Whitney Biennial in New York. He has had numerous solo shows in the United States and abroad. His work is in the collections of the Los Angeles County Museum of Art, the Museum of Modern Art in New York, and the San Francisco Museum of Modern Art. He is said to have intentionally created ceramic works that could not be discussed using an art vocabulary.

Acrobatic Frog Cup, 1968
Color lithograph (Tamarind impression 2494),
22 7/8" x 30 1/4"
Norton Simon Museum of Art,
Anonymous gift, 1969
(Not illustrated)

Jivaroland Frog Cup, 1968
Color lithograph (Tamarind impression 2495),
22" x 16 1/2"
Norton Simon Museum of Art,
Anonymous gift, 1969

Robert Rauschenberg was born in Port Arthur, Texas, in 1925 and attended Kansas City Art Institute and School of Design and Black Mountain College, where he studied with Josef Albers in the late 1940s. There, in 1952, he mounted the first "happening" with John Cage and other artists. He won first prize in the Venice Biennale in 1964. His first retrospectives were at the Jewish Museum in New York in 1963 and Whitechapel Art Gallery in London in 1964. He had solo exhibitions at the Museum of Modern Art in New York in 1966 and 1968 and at the Pasadena Art Museum in 1970. Recently he has had solo shows in New York at the Metropolitan Museum of Art and the Whitney Museum of American Art. Group exhibitions include *American Vanguard* (1961) and *Painterly Visions, 1940–84* (1985) at the Solomon R. Guggenheim Museum in New York. His

"combines" reflect his famous statement that painting relates to both art and life and that he tries to act in the gap between them.

Cardbirds I–VII, 1971
Seven collaged and screenprinted cardboard
wall reliefs (ed. 26/75),
I: 45" x 30", II: 54" x 33 1/2", III: 36" x 36",
IV: 39 1/4" x 39", V: 34" x 40", VI: 26" x 28",
VII: 33" x 33 1/4"
Published by Gemini G.E.L., Los Angeles
Norton Simon Museum of Art,
Anonymous gift, 1972

Untitled, 1969
Gelatin silver print, 17" x 14"
Norton Simon Museum of Art,
Gift of the artist, 1969
(Not illustrated)

Wall Site, 1973
Gelatin silver print, 20" x 16"
Courtesy of the artist

Allen Ruppersberg was born in Cleveland
in 1944 and attended Chouinard Art Institute. In
1970 he had a solo exhibition at the Pasadena Art
Museum, which was
followed by solo
shows at the Museum
of Modern Art in
New York in 1977
and the Los Angeles
County Museum
of Art in 1982. He
received an NEA
grant in 1976.
Ruppersberg is well

known for his appropriation of Oscar Wilde's
Portrait of Dorian Gray, which he painstakingly
hand-printed on twenty large canvases in 1974.
Allen Ruppersberg: The Secret of Life and Death, a
survey of his work from 1969 to 1984, opened at
the Museum of Contemporary Art, Los Angeles,
in 1985 and traveled to the New Museum of
Contemporary Art in New York. His work has
been in many solo and group exhibitions in
America and Europe.

Seeing and Believing, 1972
Color photographs, paper
Six photographs, 11 5/8" x 9 1/8" each
Two sheets of paper, 8 1/2" x 11" each
Courtesy of Margo Leavin Gallery, Los Angeles

Leland Rice was born in Los Angeles in
1940 and earned his M.A. in 1969 from San
Francisco State University. He has taught in the
Bay Area and the greater Los Angeles area and
has been awarded a National Endowment for the
Arts grant and a Guggenheim Fellowship. In 1977
The Photography of Leland Rice was held at the
Hirshhorn Museum
and Sculpture Garden,
Washington, D.C.,
and traveled to the
Oakland Museum.
His photographs of
the Berlin Wall were
exhibited at the San
Francisco Museum of
Modern Art in 1987
and at many other
venues. Among his
group exhibitions are two photography shows at
the Pasadena Art Museum (1972, 1973), a
Southern California photography survey at the
Los Angeles County Museum of Art (1972), and
shows at the Whitney Museum of American Art
and the Museum of Modern Art, both in New
York. Rice is known for his interest in the abstract
shape of light.

Richards Ruben was a Southern California
artist whose works have been included in major
exhibitions of abstract expressionist paintings in
the United States and abroad, including shows at
the Solomon R. Guggenheim Museum in New
York and in Paris, São Paolo, Madrid, Frankfurt,
and Stockholm. He had a solo show of his paint-
ings and drawings from the Claremont Series at
the Pasadena Art Museum in 1961. Other solo
shows have taken place at the Santa Barbara
Museum of Art and the San Francisco Museum
of Art. Among his group exhibitions are *Painting
and Sculpture in California: The Modern Era* at
the San Francisco Museum of Modern Art, which
traveled to Newport Harbor Art Museum and the
National Collection of Fine Arts, Smithsonian
Institution, Washington, D.C., in 1976–77. He
has taught at Pomona College and played an early
role in founding the legendary Ferus Gallery. Ruben
continued to alter the edges of his canvases by
stretching them over a wooden support to form
an articulated frontal plane for a physical, volu-
metric presence.

Claremont No. 55, 1961
Oil on canvas, 70 1/4" x 83 1/2"
Norton Simon Museum of Art,
Gift of Mr. Robert A. Rowan, 1962

Edward Ruscha was born in Omaha in
1937. He studied at Chouinard Art Institute in
the late 1950s and was a lecturer in painting at
University of California, Los Angeles, in the late
1960s. He received a Guggenheim Fellowship
in 1971–72, National Council on the Arts awards
in 1967 and 1978, and National Endowment for
the Arts grants in 1969 and 1978. His art was
exhibited at the Pasadena Art Museum in *New*

Painting of Common Objects in 1962 and in *West Coast, 1945–69* in 1969–70. Group exhibitions include *Painting and Sculpture in California: The Modern Era* at the San Francisco Museum of Modern Art in 1976 and *Printed Art: A View of Two Decades* at the Museum of Modern Art in New York in 1980. He has published numerous artist's books, including *Twenty-six Gasoline Stations* (1962) and *Every Building on the Sunset Strip* (1966), which recorded ordinary scenes from contemporary life in a deadpan style. Ruscha has had solo exhibitions in Los Angeles, New York, and major European cities, and his works are in the collections of major museums in America and abroad.

Annie, Poured from Maple Syrup, 1966
Oil on canvas, 55" x 59"
Norton Simon Museum of Art,
Gift of the Men's Committee, 1966

Adios, 1969
Color lithograph
(Tamarind impression 2538), 9 1/4" x 22"
Norton Simon Museum of Art,
Anonymous gift, 1972
(Not illustrated)

City, 1969
Two-color lithograph
(Tamarind impression 2536), 17" x 24"
Norton Simon Museum of Art,
Anonymous gift, 1972
(Not illustrated)

Paul Sarkisian was born in Chicago in 1928 and attended the School of the Art Institute there and Otis College of Art and Design in Los Angeles in the mid-1950s. He and his wife, Carol, had a studio in Old Pasadena through the 1960s. Sarkisian had a solo exhibition at Pasadena Art Museum in 1968, which was followed by solo shows at the Corcoran Gallery of Art, Washington, D.C. (1969); the Museum of Contemporary Art, Chicago (1972); the Museum of Contemporary Arts, Houston (1977); and other museums. Group exhibitions include *A View of the Decade* at the Museum of Contemporary Art, Chicago, in 1977 and *American Realism* at the San Francisco Museum of Modern Art, which toured the United States from 1985 to 1987. He has taught at the Pasadena Art Museum, the University of Southern California, and Art Center College of Design. Sarkisian is known as an ultra-illusionist, and his paintings, which often feature mundane objects in a collage format, have been called transcendental.

Untitled: Bob Dylan, 1966
Acrylic on canvas, 136 1/8" x 104"
Collection of the artist
(Not illustrated)

Alexis Smith was born Patricia Anne Smith in Los Angeles in 1949. She earned a B.A. from the University of California, Irvine, in 1970. She had a studio in Pasadena in the early 1970s. Her work was exhibited in *Southern California: Attitudes, 1972* at the Pasadena Art Museum, at the Whitney Biennial in New York in 1979, and

in *Avant-Garde in the Eighties* at the Los Angeles County Museum of Art in 1987, to name a few group exhibitions. Smith had a solo show at the Santa Monica Museum of Art in 1989 and a retro-

spective at the Whitney Museum of American Art, New York, in 1991, which traveled to the Museum of Contemporary Art, Los Angeles. Awards include National Endowment for the Arts fellowships in 1976 and 1987. Smith has created permanent public installations at the University of California, San Diego; the Los Angeles Convention Center; and Artpark in Lewiston, New York.

The Scarlet Letter, 1974
Paper collage, 12 3/4" x 99"
Courtesy of Margo Leavin Gallery, Los Angeles

Barbara Smith was born in Pasadena in 1931 and studied art and comparative religion at Pomona College in 1953. She earned her M.F.A. from the University of California, Irvine, in 1971. A pioneer of performance art, she created her interactive works in homes, on streets, and on beaches. Major performances include *Ritual Meal* at Stanley Grinstein's home in 1968; *Nude Frieze* at F-Space Gallery in 1970; *Feed Me* at the San Francisco Museum of Conceptual Art in 1973; *Perpetual Napkin* at the Art Institute of Chicago in 1980; *Alien Ambassador* at the Stedelijk Museum in Amsterdam in 1982; *Pageant of the Holy Squash* at the Cathedral of Saint John the Divine in New York in 1989; and *Twenty-first-Century Odyssey* in India, Australia, Norway, and Nepal from 1991 to 1993. In 1998 she was represented in the

exhibition *Out of Actions: Between Performance and the Object, 1949–1979* at the Museum of Contemporary Art, Los Angeles. Her stated intention is to restore the carnal female body and its sexuality to the sacred realm.

Full Jar/Empty Jar, 1974
Photograph of performance (artist on left)
Courtesy of the artist
(Not in exhibition)

Frederick Sommer was born in 1905 in Angri, Italy, and attended Cornell University in 1925. He had a solo exhibition at the Santa Barbara Museum of Art in 1946. His show at the Pasadena Art Museum in 1965, which traveled from Washington Gallery of Modern Art in Washington, D.C., included photographs, drawings, and objects. His work was included in *Photography at Mid-Century* at the Los Angeles County Museum of Art in 1950, *Contemporary American Photography* at the Musée d'Art Moderne in Paris in 1956, and *The Sense of Abstraction* at the Museum of Modern Art in New York in 1961. A retrospective of his work was held in 1980 at California State University, Long Beach. In 1974 he received a Guggenheim Fellowship in photography.

Paracelsus, 1959
Gelatin silver print, 13 5/16" x 10 3/16"
Norton Simon Museum of Art,
Gift of the artist, 1965

Untitled (nude), 1962
Gelatin silver print, 13 3/8" x 8 11/16"
Norton Simon Museum of Art,
Gift of the artist, 1965
(Not illustrated)

Untitled (cut paper), 1963
Gelatin silver print, 13 5/16" x 9 13/16"
Norton Simon Museum of Art,
Gift of the artist, 1965
(Not illustrated)

Don Sorenson was born in Glendale, California, in 1948 and died in 1985. He received his M.A. from California State University (CSU), Northridge, in 1973 and had an art studio in Old Pasadena in the 1960s. His Temple paintings were exhibited at CSU San Bernardino in 1982, and a memorial exhibition was held at the University of California, Irvine, in 1986. A solo exhibition of his work was held at Mount Saint Mary's College in Los Angeles in 1978. Selected group exhibitions include *Contemporary Classicism* at CSU Los Angeles in 1984, *Drawings by Painters* at Long Beach Museum of Art 1982, *Fresh Paint: Fifteen California Painters* at the San Francisco Museum of Modern Art in 1982, and *Aspects of Abstract: Recent West Coast Abstract Painting and Sculpture* at the Crocker Art Museum in Sacramento in 1979. Through geometric painting he continued to explore the potential of nonobjective painting, using bipolarity to set up unfamiliar perceptual structures.

Untitled, n.d.
Oil on canvas, 94 1/2" x 57"
Courtesy Robert Berman Gallery, Santa Monica

Frank Stella was born in Malden, Massachusetts, in 1936. He had his first solo show at Leo Castelli Gallery in New York in 1960, which was followed by shows at the Ferus Gallery, Los Angeles, in 1963 and 1965. His first solo museum exhibition took place at the Pasadena Art Museum in 1966. In 1970 and 1987 he had solo shows at the Museum of Modern Art in New York (the 1970 exhibition traveled to the Pasadena Art Museum in 1971). *Stella since 1970* originated at the Fort Worth Art Museum in Texas in 1978 and toured the United States. Among his group exhibitions are biennials in Venice and São Paulo; *New Shapes of Colour* at the Stedelijk Museum in Amsterdam in 1966; *New York Painting and Sculpture, 1940–1970* at the Metropolitan Museum of Art, New York, in 1969; *Prints from Gemini G.E.L.* at the Walker Art Center, Minneapolis, in 1974, which toured the United States; and several other major exhibitions in New York and Europe.

Damascus Gate I, 1969
Fluorescent alkyd resin on canvas, 96 1/8" x 384"
Norton Simon Museum of Art, Partial museum purchase and partial gift of the Fellows, 1969
(Not illustrated)

Hiraqla Variation III, 1969
Fluorescent acrylic on canvas, 120" x 240"
Norton Simon Museum of Art,
Gift of the artist, 1969

Ben Talbert was born in 1933 in Los Angeles and died in 1974. He attended the University of California, Los Angeles. He had his first solo show at the Pasadena Art Museum in 1961, the year he began his major assemblage *The Ace.* That year his work was also included in *The Object Makers* at Pomona College in Claremont, California. In 1964 he designed costumes and the poster for a play at the Coronet Theater on La Cienega

Boulevard. He used such objects as false teeth, a fur-covered piano stool, high heels, airplane wings, and a phonograph to create his works. Talbert was represented among the first generation of assemblage artists in the 1988 group exhibition *Lost and Found in California: Four Decades of Assemblage Art*, which was held in various venues in Los Angeles and Santa Monica. *The Ace* was included in the traveling exhibition *Forty Years of California Assemblage*, which originated at the Wight Art Gallery, University of California, Los Angeles, in 1989.

Two Nudes, 1961
Woodcut (artist's proof), 10 1/2" x 9 3/8"
Norton Simon Museum of Art,
Gift of the artist, 1964
(Not illustrated)

January 1, 1962 Triptych, 1962
Woodcut (artist's proof), 19 1/2" x 24 1/4"
Norton Simon Museum of Art,
Museum purchase, Plant Fund, 1964

Edmund Teske was born in Chicago in 1911 and was self-taught in photography. He worked as a designer, actor, makeup artist, and photographer for the theater department of Hull House in Chicago in 1934–36. As an honorary Taliesin Fellow with Frank Lloyd Wright, he established a photography workshop. He worked with the Federal Arts Project, assisted photographer Berenice Abbott, and worked in the photography department of Paramount Pictures in Hollywood. He had a solo show at Third Street Gallery in Los Angeles in 1950. His work was the subject of exhibitions at the Pasadena Art Museum and the Santa Barbara Museum of Art in 1961. He has been represented in group shows at the San Francisco Museum of Modern Art, the Los Angeles County Museum of Art, the Museum of Modern

Art in New York, and many other venues. In the mid-1960s he taught at Chouinard Art Institute in Los Angeles. Images from diverse areas and periods of Teske's life coexist in his photo-montages.

Untitled, n.d.
Gelatin silver print, 8 3/8" x 11"
Norton Simon Museum of Art,
Gift of the artist, 1969

Untitled, n.d.
Gelatin silver print, 8 3/8" x 11"
Norton Simon Museum of Art,
Gift of the artist, 1969
(Not illustrated)

Untitled, n.d.
Gelatin silver print, 20 1/16" x 13 1/16"
Norton Simon Museum of Art,
Gift of the artist, 1971
(Not illustrated)

Wayne Thiebaud was born in Mesa, Arizona, in 1920. He earned his M.A. in 1952 from Sacramento State College and worked as a sign painter, cartoonist, illustrator, designer, and art director. He has been a professor since 1967 at the University of California, Davis. He had a solo show at the Pasadena Art Museum in 1968 and a retrospective at the Phoenix Art Museum in 1976. The Walker Art Center in Minneapolis presented an exhibition of his paintings in 1981. In 1985 a retrospective opened at the San Francisco Museum of Modern Art and traveled to various cities. His work was in the São Paulo Bienal in 1987 and the 1972 Documenta in Kassel, West Germany. Among his group exhibitions are *Separate Realities: Developments in California Representational Painting and Sculpture* at the Municipal Art Gallery in Los Angeles in 1973 and *Made in USA* in 1987, which traveled to Berkeley; Kansas City, Missouri; and

Richmond, Virginia. In Thiebaud's paintings realism is translated into abstraction.

Pastry Case, 1964
Etching, 5" x 6 1/8"
Norton Simon Museum of Art,
Gift of Mr. Paul Beckman, 1967

Walasse Ting was born in Shanghai, China, in 1929. He resided in Paris in the 1950s. He received a Guggenheim Fellowship in 1970. Early solo exhibitions took place in galleries in Hong Kong (1952) and Paris (1954). In New York his work was shown at Martha Jackson Gallery in 1959 and at the Lefebre Gallery throughout the 1960s and later. His art was shown in the Carnegie International Exhibitions in 1961, 1964, 1967, and 1970. His work is in the permanent collections of the Stedelijk Museum in Amsterdam, the Art Institute of Chicago, the Museum of Modern Art in New York, and other institutions.

1 Cent Life, 1964 (detail of print by Allan Kaprow)
Loose-leaf book of 68 lithographs and 61 poems (ed. 1995/2000), 16 3/4" x 12" (page size)
Norton Simon Museum of Art,
Gift of Kornfeld and Klipstein, 1964

Michael Todd was born in Omaha in 1935 and raised in Chicago. He received his M.A. from the University of California, Los Angeles (UCLA), in 1959. He was awarded a Fulbright to Paris from 1961 to 1963 and a National Endowment for the Arts grant in 1974–75. He has taught at UCLA, the California Institute for the Arts, Art Center College of Design, and Otis College of Art and Design from the 1960s through the 1970s. Todd had a studio in Old Pasadena in the mid-

1960s, which he shared with Judy Chicago and Lloyd Hamrol. His work has been shown in solo exhibitions at venues throughout Southern California, including UCLA, the ARCO Center for the Visual Arts, Tortue Gallery, the Laguna Art Museum, and the Palm Springs Desert Museum. His work has also been seen at Hanover Gallery in London; Henri Gallery in Washington, D.C.; Hammerskjold Plaza, Pace Gallery, and Zabriskie Gallery in New York; and the Oakland Museum.

Mia Chan XVII, 1987
Lacquered steel, 92" x 81" x 30"
Courtesy of the artist

DeWain Valentine was born in Fort Collins, Colorado, in 1936 and earned his M.F.A. from the University of Colorado, Boulder, in 1960. His cast-polyester works were in a solo show at the Pasadena Art Museum in 1970. From 1976 on he created laminated glass works, which were seen in solo exhibitions at the Los Angeles County Museum of Art in 1979 and the Madison Art Center in Wisconsin in 1983, among many other major museums. Selected group exhibitions include *The Industrial Edge* at the Walker Art Center, Minneapolis, in 1969 and *California Light and Space* at Lonny Gans and

Associates in 1981. His nonobjective investigations of light and perception, along with those of Robert Irwin and James Turrell, contributed to the Los Angeles style of crafted surfaces and primacy of light. He has been written about in many books, including *Sunshine Muse* by Peter Plagens (1974) and *Fifty West Coast Artists* by Henry Hopkins (1982).

Untitled—Large Slab, 1968
Cast polyester resin, 91 1/4" x 94" x 17 1/2"
Norton Simon Museum of Art,
Gift of the artist, 1969
(Not illustrated)

Peter Voulkos was born in Bozeman, Montana, in 1924 and earned his M.F.A. from the California College of Arts and Crafts in 1952. He taught at Otis College of Art and Design from 1954 to 1959, where he influenced many Southern California artists. In 1958 he had a solo exhibition at the Pasadena Art Museum. Among his many prestigious awards are the gold medal at the International Ceramic Exhibition in Cannes in 1955 and sculpture prizes in Paris in 1959 and San Francisco in 1967. He was also awarded a National Endowment for the Arts grant in 1986 and a Guggenheim Fellowship in 1984. A retrospective of his work was held at the San Francisco Museum of Modern Art in 1976. Also in that year his work was featured in the group exhibition *Two Hundred Years of American Sculpture* at the Whitney Museum of American Art in New York, which also presented the touring exhibition *Ceramic Sculpture* in 1981. He was instrumental in establishing ceramics as a sculptural medium, one that has become identified with Southern California.

Honk, 1963
Bronze, 47" x 92" x 35"
Norton Simon Museum of Art, Museum purchase with funds from the Ford Foundation, 1963

Andy Warhol was born in McKeesport, Pennsylvania, in 1928 and died in 1987. He studied pictorial design at Carnegie Institute of Technology in Pittsburgh, graduating in 1949. He worked as an illustrator for *Glamour* magazine and as a commercial artist, before helping to define pop art. He is perhaps best known for his paintings of Campbell's Soup cans and screenprints of Elvis Presley and Marilyn Monroe. Eventually he made society his subject and success his art form, promoting trendy hotspots, establishing a "Factory" for mass production of art, producing art films, and creating *Interview* magazine. His 1970 solo show at the Pasadena Art Museum toured the United States and Europe. The Museum of Modern Art in New York presented a major retrospective in 1989, which traveled to the Art Institute of Chicago. Group exhibitions include *New Painting of Common Objects* at the Pasadena Art Museum in 1962; Documenta 4 at Kassel, West Germany, in 1968; *Painterly Visions, 1940–84* at the

Solomon R. Guggenheim Museum in New York in 1985, and many other shows on pop art at major museums.

Self-Portrait, 1966
Silkscreen on paper (ed. 79/300), 23 1/8" x 23"
Norton Simon Museum of Art,
Gift of Mr. John Coplans, 1969
(Not illustrated)

Two Jackies, 1966
Silkscreen (artist's proof), 24" x 30"
Norton Simon Museum of Art,
Gift of Mr. and Mrs. Robert C. Clark, 1969
(Not illustrated)

12 Brillo Boxes, 1969 (replica of 1964 original)
Acrylic silkscreen on wood, 20" x 20" x 17" each
Norton Simon Museum of Art,
Gift of the artist, 1969

Campbell's Soup Can I, 1968
Silkscreen on paper (ed. 76/250),
35 1/2" x 23 1/8"
Norton Simon Museum of Art,
Museum purchase, 1969
(Not illustrated)

At Last a Thousand I, 1965
Lithograph (Tamarind impression 1000-A),
24" x 34"
Norton Simon Museum of Art,
Anonymous gift, 1969

Plus Ça Reste-Même, 1969
Color lithograph (Tamarind impression 2197),
22" x 28"
Norton Simon Museum of Art,
Anonymous gift, 1971
(Not illustrated)

Before Before / On / After, 1972
Vintage gelatin silver print (ed. 4/7), 41" x 40"
Courtesy of PaceWildensteinMacGill,
Los Angeles

Tom Wesselmann was born in Cincinnati in 1931. He studied at the Art Academy of Cincinnati and Cooper Union in New York. He has had many solo exhibitions since 1961, including *Early Still-Lifes, 1962–64* at Newport Harbor Art Museum, which toured the United States in 1970. *A*

Retrospective Survey, 1959–1992 toured Japan in 1993, and *Retrospective, 1959–1993* was organized in Germany in 1994 and traveled to Belgium, Spain, and France. Selected group exhibitions include *Art in a Mirror* at the Museum of Modern Art in New York in 1966, which toured the nation, and *American Pop Art* at the Whitney Museum of American Art in New York in 1974. His works were in the group exhibition *New Painting of Common Objects* at the Pasadena Art Museum in 1962 and are in the permanent collection of the Norton Simon Museum of Art. His work has been discussed in many books and articles on pop art.

Still Life #2, 1962
Oil and collage on board, 48" x 48 1/8"
Norton Simon Museum of Art,
Gift of Mr. Fred Heim, 1969

June Wayne was born in 1918 in Chicago and was self-taught as an artist. She had her first solo show of drawings and watercolors in Chicago at the age of eighteen. She became a Works Project Administration Easel Project artist. Her later work in production illustration and radio writing influenced her art, which has been described as a parallel to film noir. She had solo exhibitions at the Pasadena Art Museum in 1950 and 1952. In

1958 she produced lithographs for a book of songs and sonnets by John Donne, which brought her recognition and helped make possible the funding for the Tamarind Lithography Workshop in Los Angeles. Wayne has significantly influenced the aesthetic and technical resurgence of lithography. In 1997 PBS produced the documentary "The World of Art: June Wayne," and in 1998 there was a fifty-year retrospective, which originated at Neuberger Museum of Art in Purchase, New York, and traveled to the Los Angeles County Museum of Art. The exhibition included her work in five media: painting, collage, printmaking, drawing, and tapestry.

William Wegman was born in Holyoke, Massachusetts, in 1942, earning his M.F.A. in 1967 from the University of Illinois, Urbana. His art was featured in two early group exhibitions: *Twenty-four Young Los Angeles Artists* at the Los Angeles County Museum of Art (LACMA) in 1971 and *Fifteen Los Angeles Artists* at the Pasadena Art Museum in 1972. He had a solo exhibition at LACMA in 1973. In 1990 *William Wegman: Paintings, Drawings, Photographs, Videotapes* traveled through Europe and was shown at the Whitney Museum of American Art in New York and the Contemporary Arts Museum in Houston. *William Wegman's Cinderella* was at the Museum of Modern Art in New York in 1993 and, along with *Little Red Riding Hood,* traveled to five venues in the United States. His photographs of dogs, which in a sense represent his

persona, bring to "high art" the fun of popular entertainment.

Charles White was born in Chicago in 1918 and died in 1979. He studied at the Art Institute of Chicago, the Art Students League in New York, and schools in Mexico. He had a studio in the Castle Green in Old Pasadena in the 1960s. He was chairman of the drawing department of Otis Art Institute in Los Angeles from 1977 to 1979. He was also distinguished professor at Howard University Graduate School of the Arts in Washington, D.C., the site of his mural *Five Great Americans, or Progress of the American Negro.* His mural titled *Dr. Mary Mcleod Bethune—Last Will and Testament* is at the public library named for Bethune in Los Angeles. White was the subject of a film in 1979, and a park in Altadena was

named after him in 1980. His work has been the focus of many solo exhibitions and has been included in group shows at the Whitney Museum of American Art in New York; the Corcoran Gallery of Art in Washington, D.C.; the Los Angeles County Museum of Art; the Santa Barbara Museum of Art; and Otis Art Institute. In his lifetime he received several fellowships, and after his death several scholarships were created in his honor.

Untitled, 1970 (detail)
Two lithographs (Tamarind impressions 2873 and 2873 state II), 22 1/6" x 16" each
Norton Simon Museum of Art,
Anonymous gift, 1972

John White was born in San Francisco in 1937 and earned his M.F.A. in 1969 from Otis College of Art and Design. He was director of the Calesthetics Performance Troop in 1972, the year

he was represented in the exhibitions *Fifteen Los Angeles Artists* at the Pasadena Art Museum and *Twenty-four Young Los Angeles Artists* at the Los Angeles County Museum of Art (LACMA). His environmental works – including sculpture, events, and choreography – have been staged at

LACMA, among other venues. In 1998 *Beyond the Pink* was performed at Barnsdall Art Center in Los Angeles, and *Site Now,* at the University of California, Irvine. His performances have included *Rachel Chronicles, Damaged Goods, Leftovers, Confectional and Confessional,* and *The Annotated Lipchitz.* He has also had solo exhibitions of his drawings, installations, sculpture, and paintings throughout California and has received several National Endowment for the Arts grants.

Sock Performance (Diagram), 1972
Ink on paper, 18" x 22"
Courtesy of the artist
(Not in exhibition)

Guy Williams was born in San Diego in 1932. He became an instructor at Chouinard Art School in 1965 and then taught at Claremont Graduate School, Claremont, California. His work was exhibited at the Pasadena Art Museum on a number of occasions, including *Pacific Profiles* (1961) and *Southern California: Attitudes 1972.* More recently he has had solo shows at Kiyo Higashi Gallery in Los Angeles and the Santa Barbara Museum of Art. A selection of his works was exhibited at Los Angeles Municipal Art

Gallery in 1982 and at Los Angeles Institute of Contemporary Art in 1976. Group exhibitions include *Intersections: Art and Play* at the Armory Center for the Arts in 1993 and *California Painting and Sculpture: The Modern Era* at the San Francisco Museum of Modern Art and the National Collection of Fine Arts, Smithsonian Institution, Washington, D.C., in 1976. His work is found in major Southern California collections.

Navy Street #25, 1975–80
Acrylic with paper and stencil on canvas,
45" x 78 1/4"
Orange County Museum of Art, Anonymous gift

Mason Williams is a guitarist, composer, comedy writer, and performer who created a life-size poster of a photograph of a Greyhound bus in the late 1960s. This artist's book is in the collection of the Museum of Modern Art in New York and the Norton Simon Museum. Williams is

famous for the song "Classical Gas," which won Grammys in 1968 for best instrumental theme and best performance. He also won an Emmy for *The Smothers Brothers Comedy Hour* in 1969 and a Writers Guild Award for a Steve Martin commercial in 1981. He has also written for *Saturday Night Live,* Andy Williams, Glen Campbell, Dinah Shore, Roger Miller, and Petula Clark, and he created the Pat Paulsen for President satire in 1968. His most recent recording is "A Gift of Song" (1992).

Bus Book, 1967
Silkscreen on paper (ed. 2/200),
15" x 17 1/4" x 5 1/4" (box)
Norton Simon Museum of Art,
Gift of the artist, 1968

Emerson Woelffer was born in Chicago in
1914 and attended the Art Institute of Chicago
before joining the Works Projects Administration
arts program in 1938. Exhibitions include a retro-
spective at the Pasadena Art Museum in 1962 and
solo shows at the Newport Harbor Art Museum,
Newport Beach, California, in 1974 and Otis

College of Art and
Design, Los Angeles,
in 1992. Group
exhibitions include
*Nine Senior Southern
California Painters*
at the Los Angeles
Institute of
Contemporary Art
in 1974; *Southern
California Artists,
1940–1980* at the Laguna Art Museum, Laguna
Beach, California, in 1981; and *Illusive Paradise* at
the Museum of Contemporary Art in Los Angeles
in 1997. *Post Painterly Abstraction,* which originated
at Los Angeles County Museum of Art in 1964
and toured, also included Woelffer's art. He has
taught at Otis College of Art and Design, the
California Institute of the Arts, Chouinard Art
Institute, and other institutions. He has been
awarded fellowships by the National Endowment
for the Arts and the Guggenheim Foundation.

Black and White, 1959
Oil on canvas, 39 1/2" x 27 3/4"
Norton Simon Museum of Art,
Gift of Mr. and Mrs. Paul Kantor, 1966

Tom Wudl was born in Bolivia in 1948 and
immigrated to the United States at age ten. He
received his B.F.A. from Los Angeles's Chouinard
Art Institute in 1970, after which he began a
teaching career at institutions like Art Center
College of Design in Pasadena; the University of
California, Los Angeles; and Claremont Graduate
School. In 1972 he was included in the Pasadena
Art Museum's show *Fifteen Los Angeles Artists* and
in the same year was awarded the Young Talent
Award by the Los Angeles County Museum of
Art. LACMA also featured his work in the 1987
show *The Spiritual in Art: Abstract Painting, 1890–
1985.* A colorist, he continually experiments with
media and techniques. His paintings, drawings,
photographs, and ceramic wall pieces reflect an
interest in metaphysics.

Untitled, 1973
Gold leaf and paint on punched paper,
58" x 74 1/2" x 3"
Courtesy Cirrus Gallery, Los Angeles

Jack Youngerman was born in Saint Louis
in 1926 and earned his B.A. from the University
of Missouri, Columbia, in 1947. He attended
school in Paris and designed the stage set for
Deathwatch by Jean Genet in New York in 1958.
He received a National Endowment for the Arts
grant in 1972 and a Guggenheim Fellowship in
1976. His first solo exhibition was in Paris in
1951, followed by many in New York galleries.
In 1986 he had a solo show at the Solomon R.
Guggenheim Museum in New York. Among his
group exhibitions are *Abstract Expressionists and
Imagists* at the Guggenheim Museum in 1961,
American Drawings at the Guggenheim in 1964,
and *Twentieth-Century Art* at the National Gallery
of Art in Washington, D.C., in 1989. In the late
1950s Youngerman was a post-painterly abstract
artist, later resolving his forms into landscape

panorama and translating nature into pattern.
He works with shaped canvases, steel sculpture,
and wooden cutouts, among other media.

Red-Vermillion, 1961
Oil on canvas, 76" x 97 3/4"
Norton Simon Museum of Art,
Gift of Mr. Robert Halff, 1973

Peter Zecher was born in Oakland in 1945.
He earned his B.A. at the University of California,
Berkeley, in 1968, the same year he was featured
in the San Francisco Museum of Art's Society for
the Encouragement of Contemporary Art Award
Show. He has had recent solo exhibitions at
Newspace and Zero One galleries in Los Angeles.
Group exhibitions include *New Surrealism* at the
La Jolla Museum of Contemporary Art, La Jolla,
California, in 1971; *Twenty-four from Los Angeles*
at the Municipal Art Gallery in Los Angeles in
1974; *Serra,
Wall, Zecher* at
San Francisco
Art Institute in
1974, *Frederick
Weisman
Collection of
California Art* at
California State
University, Long
Beach, in 1978,
and *A Southern*

California Collection at Cirrus Gallery in Los
Angeles. His work is in the collections of the San
Francisco Museum of Modern Art and other
institutions.

Tripod VI, 1974
Corrugated kraft paper and paint, 45" x 45" x 45"
Collection of Mary Zecher

Connie Zehr was born in Evanston, Illinois, in 1938. She received her B.F.A. from Ohio State University, then moved to California in the mid-1960s. In 1972 she created her sumptuous room-sized installation *Eggs,* involving eggs and sand, for the Pasadena Art Museum's exhibition *Fifteen Los Angeles Artists.* She also had a solo show at Municipal Art Gallery in Los Angeles in 1985 and showed at various galleries in Southern California. Group exhibitions include *Lost and Found in California: Four Decades of Assemblage Art* at Pence Gallery in Santa Monica in 1988; *Southern California: The Conceptual Landscape* at Madison Art Center in Wisconsin in 1994; *Body, Mind, and Spirit: Eight Sculptors* at Scripps College, Claremont, California, in 1995; and *Sensuality in the Abstract* at the Los Angeles Municipal Art Gallery in 1997. She has taught at

various Southern California universities and is currently teaching at Claremont Graduate School. She has received three grants from the National Endowment for the Arts and has taken on various civic projects.

Eggs, 1972
Eggs and sand, 3" x 416" x 348"
(original dimensions)
Courtesy of the artist

Chronology

Compiled by Michelle Deziel

1920s

August 14, 1924: The Pasadena Art Institute (PAI) is founded. The board of directors purchases 9 1/2 acres of land and a twenty-two-room Victorian house, which is used as a museum, in Carmelita Park (at Colorado and Orange Grove Blvds.). The primary focus of the institute is the conservation and preservation of this site.

1940s

1942 The Pasadena Art Institute merges with a younger group known as the Pasadena Museum Association, boasting a membership of more than five hundred. The Institute relocates to 46 N. Los Robles Ave., site of Grace Nicolson's Chinese House and Emporium (presently the Pacific Asia Museum).

1944 Lorser Feitelson joins the faculty of the Art Center School.

1946 John McLaughlin settles in Dana Point.

1948 Billy Al Bengston settles in Los Angeles.

1950s

PAM Staff
1951–53: Director—John Palmer Leeper
1953–57: Director—Joseph Fulton
1957–63: Director—Thomas Leavitt

Local and Museum Events

1952 Lee Mullican settles in Los Angeles.

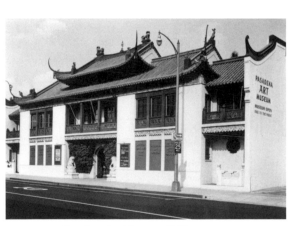

Pasadena Art Museum, 1962.

1953 The Pasadena Art Institute receives Galka Scheyer's Blue Four Collection. The bequest includes more than three hundred important works by Lyonel Feininger, Alexei Jawlensky, Wassily Kandinsky, and Paul Klee.

1953 William Brice joins the faculty at UCLA.

1953 Edward Kienholz moves to Los Angeles.

1954 Peter Voulkos arrives in Los Angeles and accepts the position of chairman of the newly established ceramics department at the Los Angeles County Art Institute (now Otis College of Art and Design). Among his students are Billy Al Bengston, Kenneth Price, and John Mason.

1954 Walter Hopps opens his first gallery, the Snydell Studio, in Brentwood.

1954 The Pasadena Art Institute is reorganized to focus on acquiring and exhibiting modern art, primarily works created after 1945. The name is changed to the Pasadena Art Museum (PAM).

1955 John Altoon settles in Los Angeles.

1955 Kienholz opens the Now Gallery at the Turnabout Theater, West Hollywood. He also arranges exhibitions of work by local artists in the entranceway of the Coronet Theater in West Hollywood.

1956 Lorser Feitelson hosts a television series, *Feitelson on Art,* which airs on the NBC network for the next seven years.

1956–61 Frederick Hammersley teaches painting classes at the Pasadena Art Museum.

1957 Llyn Foulkes settles in Los Angeles.

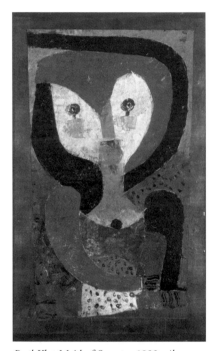

Paul Klee, Maid of Saxony, *1922, oil on oil-primed muslin, 14 1/4" x 8 5/8". The Blue Four Galka Scheyer Collection, Norton Simon Museum of Art.*

1957 The Ferus Gallery, located at 736A N. La Cienega Blvd., is founded by Walter Hopps and Edward Kienholz. Kienholz moves his studio into the back of the gallery.

1957 Voulkos and John Mason share a studio on Glendale Blvd., Los Angeles.

1957 Wallace Berman's exhibition at the Ferus Gallery is shut down by police for showing what is considered to be obscene material. Berman is arrested and fined.

1957 George Herms completes a full "assemblage-environment" in Hermosa Beach, where he lives in close association with a group of poets and artists, including Berman.

1957 Ben Talbert establishes a studio in Venice Beach.

1958 Connor Everts opens the Exodus Gallery in San Pedro.

1958 The Pasadena Art Museum founds the Graphic Arts Exhibition Program in memory of Edward C. Crossett. Biennial print exhibitions are presented at the museum.

1959 Irving Blum becomes a partner at the Ferus Gallery.

Selected Exhibitions

1953 *Helen Lundeberg,* PAI, November 22–December 22.

1953 *John McLaughlin* (first one-person show), Felix Landau Gallery, Los Angeles.

1954 *Clinton Adams,* PAM, January 2–31.

1954 *Printmakers of Pasadena,* PAM, November 12–December 12.

1954 *Douglas McClellan,* PAM, June 25–July 27.

1954 *Leonard Edmondson,* PAM, October 8–December 16.

1955 *California Design,* PAM, November 28–January 9.

1955 *Ynez Johnston,* PAM, December 17–January 16.

1955 *Richards Ruben,* PAM, April 1–May 8.

1956 *California Design II,* PAM, January 22–March 4.

1956 *John McLaughlin,* PAM, April 20–May 20.

1957 *Craig Kauffman,* Ferus Gallery, Los Angeles.

1957 *California Design III,* PAM, January 27–March 3.

1958 *Ed Moses,* Ferus Gallery, Los Angeles.

1958 *Edward Kienholz,* Exodus Gallery, San Pedro.

1958 *John Altoon* (first one-person show in Los Angeles), Jay DeFeo, and Edward Kienholz, Ferus Gallery, Los Angeles.

1958 *Ceramics, Sculpture, and Painting by Peter Voulkos,* PAM, December 16–January 25.

1958 *Jay DeFeo,* Dilexi Gallery, Los Angeles.

1959 *Ed Kienholz and Billy Al Bengston,* Ferus Gallery, Los Angeles.

1959 *Sam Francis,* PAM, March 3–April 10.

1959 *Walter Askin,* PAM, November 29–January 4.

1959 *Four Abstract Classicists,* Los Angeles County Museum of History, Science, and Art. Artists include Karl Benjamin, Lorser Feitelson, Frederick Hammersley, and John McLaughlin.

1960

PAM Staff

President of the Board of Trustees—Eudorah Moore
Director—Thomas Leavitt
Curator of Education—Robert Ellis
Assistant Curator of Education—Virginia Hoadley

Local and Museum Events

Tamarind Lithography Workshop is established in Los Angeles by artist June Wayne with a grant from the Ford Foundation.

Henry Hopkins opens the Huysman Gallery on La Cienega Blvd., Los Angeles.

Virginia Dwan opens the Dwan Gallery in Westwood.

Peter Alexander settles in Venice Beach.

Billy Al Bengston moves his studio to Venice Beach.

Selected Local Exhibitions

California Design VI, organized by Robert Clemens Niece, PAM, January 10–February 21.

Second Biennial Print Exhibition of the Pasadena Art Museum, PAM, February 5–April 10.

Mark Tobey Retrospective, organized by the Seattle Art Museum, PAM, February 7–March 9.

Connor Everts, PAM, April 13–May 18.

Georges Braque, PAM, April 20–June 5.

Ceramic Sculpture by John Mason, PAM, May 31–July 6.

Robert Irwin, PAM, July 13–August 31.

Richard Diebenkorn, PAM, September 6–October 6.

Thirty California Artists, PAM, November 1–30.

Paintings by Walter Askin, PAM, November 30–January 4.

1961

PAM Staff

President of the Board of Trustees—Eudorah Moore
Director—Thomas Leavitt
Curator of Education—Robert Ellis

Local and Museum Events

Larry Bell creates the first shaped canvases on the West Coast.

George Herms moves to Topanga Canyon.

Llyn Foulkes settles in Eagle Rock.

Billy Al Bengston joins the faculty at the Chouinard Art Institute.

The Chouinard Art Institute merges with the Los Angeles Conservatory of Music with the guidance and support of Roy and Walt Disney and becomes the California Institute of the Arts (CalArts).

Lee Mullican joins the faculty at UCLA.

John Altoon establishes a studio in Venice Beach.

Selected Local Exhibitions

California Design VII, PAM, January 15–February 26.

Llyn Foulkes (first one-person show), Ferus Gallery, Los Angeles.

Paintings by Frederick Hammersley, PAM, January 11–February 15.

Hassel Smith Paintings, PAM, March 14–April 15.

German Expressionism, PAM, April 25–June 4.

Edward Kienholz: Recent Works, organized by *Walter Hopps,* PAM, May 17–June 21.

Pacific Profile, organized by Constance Perkins, PAM, June 11–July 26. Show of forty young West Coast painters from Seattle to San Diego.

Photographs by Edmund Teske, PAM, August 9–September 12.

Paintings by Robert Ellis, PAM, September 27–October 26.

Richards Ruben Paintings, PAM, October 22–November 15.

James Strombotne, PAM, October 31–November 30.

Paintings by Lee Mullican, PAM, November 21–December 27.

1962

PAM Staff

President of the Board of Trustees—Eudorah Moore
Director—Thomas Leavitt
Curator of Art—Walter Hopps
Curator of Design—Eudorah Moore
Curator of Education—Robert Ellis

Local and Museum Events

Sam Francis settles in Santa Monica.

Allen Ruppersberg arrives in Los Angeles.

John Altoon joins the faculty at CalArts.

Controversy over George Herms's piece *Macks,* which is included in *Directions in Collage* at PAM. The American Legion demands that the piece be removed from the show on the grounds that it desecrates the American flag. The museum is broken into, and the flag is ripped from the piece. The show continues with a note by the artist in place of the flag.

Vija Celmins arrives in Los Angeles and establishes a storefront studio in Venice.

Billy Al Bengston joins the faculty at UCLA.

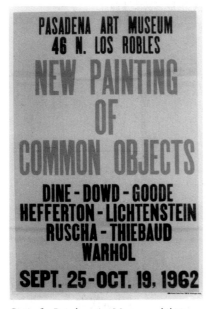

Poster for Pasadena Art Museum exhibition organized by Walter Hopps, 1962.

Special Events Held at PAM

September 11: *Now—An Environment,* a performance directed by Richards Ruben.

Selected Local Exhibitions

Paintings by William Brice, PAM, January 23–March 7.

Ynez Johnston: The Travels of Sage Narada, PAM, January 24–March 7.

Robert Motherwell Retrospective (first American retrospective), PAM, February 18–March 11. Forty-seven works from 1941 to 1961.

California Design VIII, organized by Eudorah Moore and Elisabeth Hanson, PAM, March 25–May 6.

John Altoon, PAM, May 16–June 20.

Larry Bell (first one-person show), Ferus Gallery, Los Angeles.

Directions in Collage: Artists in California, PAM, June 20–July 17. Artists include George Herms, Fred Mason, Richard Pettibone, and Ben Talbert.

A Profile of Young West Coast Painters, PAM, June 19–July 20.

Kurt Schwitters: A Retrospective Exhibition, organized by the Museum of Modern Art, PAM, June 20–July 17.

The Pasadena Art Museum: Progress and Directions, PAM, July 25–September 5. A review of important exhibitions of past seasons, a wide selection from the museum's permanent collection, and a forecast of future presentations.

Andy Warhol (first commercial show), Ferus Gallery, Los Angeles.

Ben Talbert: Woodcuts, PAM, July 10–August 8.

Llyn Foulkes: Recent Paintings and Graphic Works (first one-person museum exhibition), PAM, September 18–October 28.

Twentieth-Century Sculpture by European Masters, PAM, September 25–November 9.

New Painting of Common Objects (first large-scale museum pop art exhibition), organized by Walter Hopps, PAM, September 26–October 19. Artists include Jim Dine, Robert Dowd, Joe Goode, Phillip Hefferton, Roy Lichtenstein, Ed Ruscha, Wayne Thiebaud, and Andy Warhol.

U.S. Abstract Expressionism, PAM, September 25–November 19.

Emerson Woelffer Retrospective, PAM, October 23–November 18.

Jasper Johns (first one-person show on West Coast), Everett Ellin Gallery, Los Angeles.

Joe Goode: Milk Bottles, Dilexi Gallery, Los Angeles.

1963

PAM Staff

President of the Board of Trustees—
 Harold Jurgensen
Director (through August)—Thomas Leavitt
Curator of Art—Walter Hopps
Curator of Education—Robert Ellis
Curator of Prints—Margaret Smith

Local and Museum Events

Rico Lebrun dies of cancer in his Malibu home.

Andy Warhol visits Los Angeles and shoots part of his film *Tarzan and Jane Regained...Well Sort Of* at Wallace Berman's house on Crater Lane in Topanga Canyon. Berman and son Tosh appear in the film.

Ed Ruscha moves to Echo Park in Los Angeles.

Marcel Duchamp visits Los Angeles on the occasion of his retrospective exhibition at PAM.

Selected Local Exhibitions

Ceramics by Harrison McIntosh, PAM, January 9–February 3.

Wassily Kandinsky (1866–1944): A Retrospective, PAM, January 16–February 17.

Llyn Foulkes, Rolf Nelson Gallery, Los Angeles.

Antoni Tàpies, PAM, March 19–April 21.

Viennese Expressionism, PAM, March 19–April 21.

Ronald Garrigues, PAM, July 3–August 3.

Emil Nolde, organized by the Museum of Modern Art, PAM, July 21–September 1. The largest exhibition to date of the artist's work held in the United States

Marcel Duchamp Retrospective (first full-scale retrospective exhibition), organized by Walter Hopps, PAM, October 8–November 3.

John McLaughlin Retrospective, organized by Walter Hopps, PAM, November 12–December 12.

Hard Edge & Emblem: New York, England, America, PAM, November 12–December 16. Artists include Billy Al Bengston, John Coplans, Frank Stella, and others.

Andy Warhol, Ferus Gallery, Los Angeles.

Ed Ruscha (first one-person show), Ferus Gallery, Los Angeles.

Claes Oldenburg (first one-person show on the West Coast), Dwan Gallery, Westwood.

Six More, Los Angeles County Museum of History, Science, and Art, organized by Lawrence Alloway. This exhibition focuses on pop art.

West Coast artists include Billy Al Bengston, Joe Goode, Philip Hefferton, Mel Ramos, Ed Ruscha, and Wayne Thiebaud.

George Herms, Aura Gallery, Pasadena.

1964

PAM Staff
President of the Board of Trustees—
　　Harold Jurgensen
Director—Walter Hopps
Curator of Art—James Demetrion
Curator of Design—Eudorah Moore
Curator of Prints—Margaret Smith
Curator of Education—Harold Friedly
Preparator—Harold Glicksman

Museum and Local Events

Pasadena Art Museum trustees hire architects Thornton Ladd and John Kelsey to design a new museum to be built on the Carmelita Park site (at Orange Grove and Colorado Blvds.).

Wallace Berman makes his first Verifax collage.

Conner Everts's exhibition of semi-abstract drawings at the Zora Gallery, Beverly Hills, is closed down by police. Everts is tried for obscenity and acquitted but is dismissed from his position at CalArts.

Ron Davis settles in Los Angeles.

Llyn Foulkes moves his studio to DeLacey and Colorado Blvds. in Pasadena.

First of the Encounters Series concerts is held at the Pasadena Art Museum. The program features Cathy Berberian and Luciano Berio.

Marcel Duchamp, Bottle Rack, *1963, replica of 1914 original, Norton Simon Museum of Art.*

Shirley and Wallace Berman and George and Louise Herms at George Herms's opening at Aura Gallery, Pasadena, 1963.

Rembrandt Etchings, PAM, January 21–March 1.

New American Sculpture, organized by Walter Hopps, PAM, February 11–March 7.

Alexei Jawlensky: A Centennial Exhibition, organized by James Demetrion, PAM, April 14–May 24.

Ten Southern Californians, PAM, June 2–July 5. A selection of new work exploring new formats by artists from Southern California.

Imprint, PAM, October 6–November 6. A set of exhibitions highlighting contemporary work in the graphic arts.

A View of the Century, organized by Walter Hopps, PAM, November 24–December 19. A brief history of modern art from Cézanne to de Kooning.

1965

PAM Staff
President of the Board of Trustees—Robert A. Rowan
Director—Walter Hopps
Curator of Art—James Demetrion
Curator of Design—Eudorah Moore
Curator of Education—Gwenda Davies

Local and Museum Events

La Cienega Blvd. between Santa Monica Blvd. and Melrose Ave. is an art community "hot spot," with more than twenty-five galleries lining the street. The galleries stay open to the public on Mondays until 10 p.m.

Artforum, a magazine focusing on West Coast art, moves from San Francisco to Los Angeles, occupying an office above the Ferus Gallery on La Cienega Blvd.

Wallace Berman moves to Topanga Canyon, where he holds studio exhibitions of his work.

George Herms moves to Topanga Canyon.

Hassel Smith settles in Los Angeles and joins the faculty at UCLA.

The Los Angeles County Museum of Art opens on Wilshire Blvd., with Maurice Tuchman as curator of modern art and Henry Hopkins as curator of exhibitions and publications.

Ron Davis moves his studio to Fair Oaks Ave., Pasadena.

DeWain Valentine settles in Venice Beach.

Ed Ruscha moves his studio to Western Ave., Los Angeles.

Tony DeLap moves to Corona Del Mar to help John Coplans create a studio art program for the University of California, Irvine. He is hired as an instructor.

Llyn Foulkes and Judy Chicago (née Gerowitz) share a studio on Raymond Ave. and Colorado Blvd., Pasadena.

The Pasadena Art Museum, under the direction of Walter Hopps, is selected by the United States Information Agency to organize and represent the United States in an exhibition in São Paulo, Brazil, in which fifty-four nations participate. Artists from Los Angeles include Larry Bell, Billy Al Bengston, and Robert Irwin.

Special Events Held at PAM

Encounters Series concerts include performances by John Cage with composer-pianist David Tudor, Harry Partch, and Arnold Schoenberg.

Selected Local Exhibitions

Jasper Johns, PAM, January 12–February 7.

California Design IX, organized by Eudorah Moore, PAM, March 28–May 9.

Frederick Sommer, organized by the Washington Gallery of Modern Art, PAM, May 25–June 27.

Käthe Kollwitz, PAM, July 1–August 1.

Three American Painters: Kenneth Noland, Frank Stella, Jules Olitski, organized by the Fogg Art Museum, PAM, July 6–August 1.

Larry Rivers Retrospective, organized by Sam Hunter, PAM, August 10–September 5.

VIII São Paulo Bienal, organized by Walter Hopps, September 4–November 28.

The Responsive Eye, organized by the Museum of Modern Art, PAM, September 28–November 7.

Ronald Davis (first one-person show), Nicholas Wilder Gallery, West Hollywood.

Mark di Suvero (first one-person show), Dwan Gallery, Westwood.

Richard Pettibone (first one-person show), Ferus Gallery, Los Angeles.

Peter Voulkos, Los Angeles County Museum of Art, Los Angeles.

John McCracken (first one-person show), Nicholas Wilder Gallery, West Hollywood.

1966

PAM Staff
President of the Board of Trustees—Robert A. Rowan
Director—Walter Hopps
Curator of Art—James Demetrion
Curator of Prints—Margaret Smith
Curator of Education—Gwenda Davies
Music Director—Leonard Stein

Local and Museum Events

John Altoon teaches life drawing classes at PAM.

February: Irving Petlin organizes the *Artists' Peace Tower,* protesting the war in Vietnam. Mark di Suvero supervises the erection of a large tower on a vacant lot on the corners of La Cienega and Sunset Blvds.

The Ferus Gallery closes.

Gemini G.E.L. (Graphic Editions Limited) is established by Kenneth Tyler, Sidney Felsen, and Stanley Grinstein on Melrose Ave. in Los Angeles.

Richard Diebenkorn moves to Santa Monica and joins the faculty at UCLA.

Controversy surrounding the Kienholz retrospective exhibition organized by Maurice Tuchman at the Los Angeles County Museum of Art. The county supervisors attempt to shut down the exhibition because of objections to the content of Kienholz's *Back Seat Dodge '38.* The museum refuses to remove the piece from the show, and Kienholz defends his work to the media. The show opens with the work intact.

PAM education and curatorial departments discuss a wide range of topics relating to the museum every Friday evening on the local radio station KPOC.

The museum receives the Frank Lloyd Wright Collection of Japanese Prints from a group of private donors.

Encounters Series concerts include performances by Don Ellis, Morton Feldman, Charles Ives, Karl Kohn, and Karlheinz Stockhausen.

Special Events Held at PAM

August 16–20: Experimental Arts Workshop, founded in 1964 by composers Joseph Byrd and Michael Moore and sculptors Roger Zimmerman and Eric Orr, creates a musical "environment" in the auditorium.

November 14: Llyn Foulkes's rock band performs at the Men's Committee Purchase Party.

Selected Local Exhibitions

Contemporary Posters, PAM, January 18–February 20. Artists include Wallace Berman, Michael McClure, and Ben Talbert.

Contemporary Selections from the Mr. and Mrs. Robert Rowan Collection, PAM, February 25–March 3.

Frank Lobdell, PAM, March 15–April 10.

Edward Kienholz, Los Angeles County Museum of Art, organized by Maurice Tuchman.

Lyonel Feininger Memorial Exhibition, organized by James Demetrion, PAM, April 27–May 29.

Bruce Nauman (first one-person show), Nicholas Wilder Gallery, West Hollywood.

Allan Kaprow: Self Service, A Happening by Allan Kaprow, PAM, June 1–September 1.

Nine California Artists, PAM. Artists include John Altoon, Jay DeFeo, Richard Diebenkorn, Sam Francis, Alvin Light, Frank Lobdell, Richards Ruben, and Peter Voulkos, July 6–December 2.

René Magritte, PAM, August 2–September 4.

Recent Paintings by Frank Stella, organized by Walter Hopps, PAM, October 18–November 20.

Contemporary Sculpture, PAM, October 18–November 20. Artists include Larry Bell, Donald Judd, and Barnett Newman.

Paul Tuttle Retrospective, organized by Eudorah Moore, PAM, December 6–January 3.

Jerry McMillan Photography, PAM, December 13–January 15.

Vija Celmins (one-person show), David Stuart Galleries, Los Angeles.

1967

PAM Staff
President of the Board of Trustees—Robert A. Rowan
Director—James Demetrion
Curator of Art—John Coplans
Curator of Prints—Margaret Smith
Curator of Education—Gwenda Davies
Assistant Curator—Barbara Berman

Local and Museum Events

Wallace Berman appears on the cover of the Beatles' album *Sgt. Pepper's Lonely Hearts Club Band.*

Artforum magazine relocates to New York.

California Design Program, began in 1954, relocates to Northern California.

Ground is broken at the Carmelita Park site for the new Pasadena Art Museum.

The Fellows of the Pasadena Art Museum is formed for the express purpose of providing funds for the acquisition of works of art for the museum's permanent collection.

Special Events Held at PAM

Summer: Connor Everts hosts a series of special discussions titled Experimental Visual Arts Lab.

October 12–14: Allan Kaprow, *Fluids: A Happening,* PAM. Performance takes place at many different locations throughout Los Angeles and Pasadena.

Encounters Series concerts include performances by Luciano Berio, Pierre Boulez, Toshi Ichiyanagi, and William Kraft.

Selected Local Exhibitions

Joseph Cornell, organized by Walter Hopps, PAM, January 9–February 11.

Left to right: Pasadena Art Museum Assistant Curator Barbara Berman, André Malraux, and U.S. Ambassador Bohlen at the V Paris Bienniale.

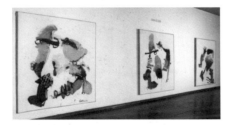

*John Altoon exhibition,
Pasadena Art Museum, 1968.*

*Thomas and Melinda Terbell, back,
Robert and Carolyn Rowan, front, Pasadena
Art Museum, 1970.*

Paul Klee Retrospective, organized by the Solomon R. Guggenheim Museum, PAM, February 21–April 2.

Roy Lichtenstein (first one-person museum exhibition), organized by John Coplans, PAM, April 18–May 28.

UCLA Photographers: Students of Robert Heinecken and Edmund Teske, PAM, March 1–April 2.

Jules Olitski, organized by the Corcoran Gallery of Art, PAM, July 25–August 27.

Mason Williams: Bus, PAM, August 29–September 7.

Jim Turrell: Light as Form and Structure, PAM, September 7–October 8.

Allan Kaprow (first one-person museum exhibition), organized by Barbara Berman, PAM, September 15–October 22. Featuring twenty-five works and three environments of the early 1960s.

Cézanne Watercolors, organized by John Coplans, PAM, November 11–December 10.

V Paris Biennial, PAM, November 28–December 31. Artists include Llyn Foulkes, Craig Kauffman, John McCracken, and Ed Ruscha. Foulkes is awarded first prize in painting.

Paintings by Clyfford Still from the Weisman Collection, PAM, November 11–December 10.

American Sculpture of the Sixties, organized by Maurice Tuchman, Los Angeles County Museum of Art. Featuring work by Judy Gerowitz (later Judy Chicago).

1968
PAM Staff
President of the Board of Trustees—Robert A. Rowan
Director—James Demetrion
Curator of Art—John Coplans
Curator of Education—Gwenda Davies
Assistant Curator—Barbara Berman

Local and Museum Events

DeWain Valentine collaborates with Hastings Plastics of Santa Monica to create the first large-scale resin castings.

Encounters Series concerts include performances by Earle Brown, Ingolf Dahl, Henri Pousseur, and La Monte Young.

Selected Local Exhibitions

John Altoon, organized by the San Francisco Museum of Art, PAM, January 9–February 4.

Robert Irwin: New Paintings, organized by John Coplans, PAM, January 16–March 10.

Wayne Thiebaud Retrospective, organized by John Coplans, PAM, February 13–March 17.

California Design X, organized by Eudorah Moore, PAM, March 31–May 12.

Dennis Hopper: Bomb Drop, PAM, February 24–March 17.

Drawings by Terry Allen, PAM, May 14–June 8.

Douglas Wheeler, organized by John Coplans, PAM, May 28–June 30.

Serial Imagery, organized by John Coplans, PAM, September 17–October 27. Artists include Josef Albers, Larry Bell, Marcel Duchamp, Yves Klein, Frank Stella, and Andy Warhol.

The Sidney and Harriet Janis Collection, organized by the Museum of Modern Art, PAM, November 12–December 15. Includes more than one hundred important works of the twentieth century.

Wallace Berman (first museum show), Los Angeles County Museum of Art.

Assemblage Art in California: Works from the Late 50s and Early 60s, organized by John Coplans, University of California, Irvine. Artists include Wallace Berman, Bruce Conner, George Herms, Edward Kienholz, and Ben Talbert.

Billy Al Bengston Retrospective (first one-person museum exhibition), Los Angeles County Museum of Art.

1969

PAM Staff

President of the Board of Trustees—Robert A. Rowan
Director (until June)—James Demetrion
Director (after June)—Thomas Terbell
Curator of Art—John Coplans
Curator of Photography—Fred Parker
Curator of Education—Nancy Watts
Assistant Curator—Barbara Berman
Assistant Curator—Rosamund Felsen

Local and Museum Events

On November 24, 1969, the Pasadena Art Museum opens in its new Carmelita Park location at 411 West Colorado Blvd., at Orange Grove Blvd. It includes an auditorium, offices for the Coleman Chamber Music Association, studio space for dance and art classes (the Pasadena Workshops), a bookshop, and a restaurant.

John Altoon dies.

Wallace Berman appears in Dennis Hopper's film *Easy Rider.*

Bruce Nauman moves his studio to Fair Oaks Ave., Pasadena.

Ed Ruscha joins the faculty at UCLA.

Joan Miró is commissioned by the Men's Committee of the Pasadena Art Museum to create a color lithograph entitled *For Pasadena* for the inauguration of the new museum.

The Repertoire Chamber Orchestra is formed at the Pasadena Art Museum to provide gifted young performers an opportunity to appear as soloists with a professional quality orchestra.

Final Exhibitions held at 46 North Los Robles

Ernest Ludwig Kirchner Retrospective, organized by the Seattle Art Museum, PAM, January 17–February 23.

Jay DeFeo: The Rose (first public showing of this work), PAM, February 4–March 2.

Billy Al Bengston: Tamarind Lithographs, PAM, March 12–April 20.

Judy Gerowitz (later Judy Chicago), PAM, April 18–June 1.

Recent Acquisitions 1969, PAM, May 6–June 1.

Inaugural Exhibitions at 411 West Colorado

West Coast, 1945–1969, organized by John Coplans, PAM, November 24–January 18.

Painting in New York, 1944–1969, organized by Alan Solomon of the Jewish Museum, New York, PAM, November 24–January 11.

Recent Acquisitions 1969, organized by John Coplans and Fred Parker, PAM, November 24–February 22.

Special Events at PAM

April 18: Steve Kent's Experimental Company Theater and Debbie Brewer stage a theatrical environmental event.

November 21: As part of the Encounters Series, the Los Angeles Philharmonic Brass and Percussion Ensembles, led by William Kraft and George Heussenstamm, perform at the opening reception of the new museum. The music is played on both sides of the roof above the entrance court.

Encounters Series concerts also include performances by Milton Babbitt, Ernst Krenek, and William O. Smith.

Selected Local Exhibitions

Allen Ruppersberg "Location Piece" (first one-person show), Eugenia Butler Gallery, Los Angeles.

Llyn Foulkes, David Stuart Gallery, Los Angeles.

1970

PAM Staff

President of the Board of Trustees—Robert A. Rowan
Director—Thomas Terbell
Director of Exhibitions and Collections—
 William Agee
Curator of Art (through March)—John Coplans
Assistant Curator—Barbara Haskell
Curator of Design—Eudorah Moore
Curator of Education—Nancy Watts
Exhibitions Coordinator/Curator of Photography—
 Fred Parker
Curator of Prints and Drawings—Rosamund Felsen
Music Director—Robert Turner

Local and Museum Events

Tamarind Lithography Workshop moves from Los Angeles to the University of New Mexico in Albuquerque and changes its name to the Tamarind Institute. Artist Clinton Adams serves as director from 1970 to 1985.

Alexis Smith graduates from the University of California, Irvine, and moves her studio to Holliston Street, Pasadena.

Judy Gerowitz changes her name to Judy Chicago.

Tamarind graduate Jean Milant founds Cirrus Editions Limited, Hollywood.

John Baldessari joins the faculty at CalArts.

March: The Gallery 8 Tea Room opens at Pasadena Art Museum.

Roger Reynolds performs the final concert of the Encounters Series at the Pasadena Art Museum.

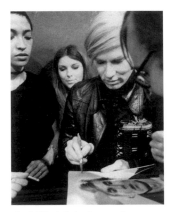

Andy Warhol signing catalogues at his retrospective, Pasadena Art Museum, 1970.

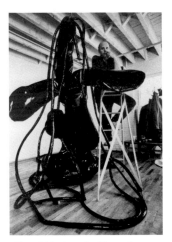

Claes Oldenburg in his studio with art for his Pasadena Art Museum exhibition.

October: Encounters Series relocates to the Beckman Auditorium, California Institute of Technology (Caltech), Pasadena.

Special Events at PAM

January 10: Judy Chicago stages a *Grand Gala Smoke Extravaganza.* This is the eighth event in a series of twelve performances entitled *Atmospheres* presented by Chicago in various California settings.

January 10: The Pasadena Art Museum begins a monthly poetry reading in a year long poetry series.

January 25: John Cage concert and performance entitled *How to Improve the World (You Will Only Make Matters Worse).* Performance inaugurates the sixth season of Encounters at the museum. Other Encounters Series concerts include performances by Larry Austin, Yvonne Loriod, Olivier Messiaen, Mel Powell, and Iannis Xenakis.

March 1: *Film Happening,* a showing of young and avant-garde filmmakers.

June: Richard Pettibone is commissioned by the Men's Committee to create a lithograph in celebration of the Andy Warhol exhibition.

July: Mark di Suvero completes a major on-site sculptural work at the museum.

November: Walter Askin is commissioned to create a screenprint in honor of the museum's first anniversary.

Selected Local Exhibitions

Music of John Cage, PAM, January 10–25.

Richard Serra, PAM, January 27–March 1.

Craig Kauffman, PAM, January 27–March 1.

Joseph Kosuth: Art as Idea / Idea as Art, PAM, January 27–March 1. Exhibition held simultaneously at fifteen locations throughout the world.

Fifty Years of Bauhaus, organized by Herbert Bayer and the Bauhaus Archive, PAM, March 17–April 26.

Peter Alexander / DeWain Valentine, organized by John Coplans, PAM, May 18–July 5.

Andy Warhol Retrospective, organized by John Coplans, PAM, May 12–June 21.

Ellsworth Kelly Lithographs (1964–66), PAM, May 12–June 21.

California Photographers, 1970, organized by Fred Parker, PAM, July 7–August 30.

Recent Works by Robert Rauschenberg, PAM, July 7–September 6.

Kandinsky Watercolors, PAM, July 21–August 30.

Selections from the Mr. and Mrs. Robert Rowan Collection, PAM, September 22–November.

John Altoon Lithographs, PAM, July 7–September 6.

Barnett Newman Memorial, PAM, July 30–August 30.

Young Artist: Allen Ruppersberg, organized by Barbara Haskell, PAM, September 22–October 25.

Joan Miró—Fifty Recent Prints, organized by the Museum of Modern Art, PAM, November 17–January 3.

Sol LeWitt, organized by Barbara Haskell, PAM, November 17–January 3.

Judy Chicago, California State University, Fullerton.

1971

PAM Staff
President of the Board of Trustees—Alfred Esberg
Director—William Agee
Associate Curator—April Kingsley
Curator of Photography—Fred Parker
Curator of Prints—Rosamund Felsen
Curator of Design—Eudorah Moore
Assistant Curator—Barbara Haskell

Funded by Walt Disney, CalArts relocates to a new site in Valencia.

Encounters Series' first season at Caltech includes Lou Harrison's adult puppet opera *Young Caesar* and a performance by Toru Takemitsu.

Special Events Held at PAM

March 5: Simone Forti Dance Concert

May 4–June 18: *Film Classics of the 1920s.*

October 26–November 26: *Museum without Walls,* a series of documentary films on the visual arts produced by Universal Studios.

November 17: *Mabou Mines,* experimental theater performance in the galleries under the direction of Lee Breur, with music by Philip Glass.

Selected Local Exhibitions

Frank Stella, organized by the Museum of Modern Art, PAM, January 19–February 28.

Young Artist: Ron Cooper, PAM, January 19–February 28.

Photography in the Twentieth Century, organized by the Eastman House of Photography, PAM, January 19–February 28.

Prints by Ed Moses, Kenneth Price, and Ed Ruscha, PAM, January 19–February 28.

California Design XI, organized by Eudorah Moore, PAM, March 14–April 25.

Manuel Alvarez Bravo, organized by Fred Parker, PAM, May 4–June 20.

Donald Judd, organized by John Coplans, PAM, May 11–July 4.

Young Artist: Laddie John Dill, organized by Barbara Haskell, PAM, May 11–June 20.

Twenty-four Young Los Angeles Artists, organized by Maurice Tuchman and Jane Livingston, Los Angeles County Museum of Art, May 11–July 4.

Picasso: Master Printmaker, organized by the Museum of Modern Art, PAM, June 29–August 29.

Milton Avery: Late Paintings (1958–1963), organized by the University of California, Irvine, PAM, June 29–August 29.

The Crowded Vacancy: Three Los Angeles Photographers, organized by Fred Parker, PAM, June 29–August 29. Artists include Lewis Baltz, Anthony Hernandez, and Terry Wild.

Ronald Davis: Recent Paintings, PAM, September 28–November 21.

The Television Environment, PAM, September 28–November 14.

Magdalena Abakanowicz, organized by Eudorah Moore, PAM, November 9–December 12.

Claes Oldenburg: Object into Monument, organized by Barbara Haskell, PAM, December 7–February 6.

1972

PAM Staff

President of the Board of Trustees—Alfred Esberg
Director—William Agee
Associate Curator—Barbara Haskell
Curator of Design—Eudorah Moore
Curator of Photography—Fred Parker

Local and Museum Events

Encounters Series concerts at Caltech include performances by Leon Kirchner and Györgi Ligeti.

Special Events Held at PAM

January–February: Claes Oldenburg films are screened at PAM each Saturday and Sunday.

March 22: Peter Yarrow concert, PAM.

April 14: Philip Glass concert, PAM.

June: *Works in Progress.* Films and videos by CalArts students are screened.

November 5: *America the Election.* Multimedia look at presidential campaigns from 1788.

Selected Local Exhibitions

Rafael Ferrer, organized by April Kingsley, PAM, January 11–February 27.

Fifteen Los Angeles Artists, organized by Barbara Haskell, PAM, February 22–March 29.

Edward Hopper (first West Coast exhibition), PAM, March 7–April 30.

Executive Order 9066, organized by the California Historical Society, PAM, April 4–May 14.

Larry Bell, organized by Barbara Haskell, PAM, April 11–June 11.

Burgoyne Diller: An American Constructivist, organized by Walker Art Center, PAM, April 25–June 18.

Tamarind Prints from the Permanent Collection, PAM, June 20–September 3.

West Coast Art from the Permanent Collection, organized by Barbara Haskell, PAM, June 20–September 3. Artists include Peter Alexander, Billy Al Bengston, Bruce Connor, Laddie John Dill, Joe Goode, Bruce Nauman, and many others.

Art of the Twentieth Century, PAM, June 27–September 24.

Robert Heinecken: Photography, organized by Fred Parker, PAM, July 11–August 6.

Los Angeles Artists, PAM, September 19–November 5.

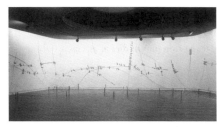

John White, Modification of Museum Wall Space, *in* Fifteen Los Angeles Artists *exhibition, Pasadena Art Museum, 1972.*

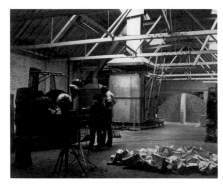

John Mason in his studio with work for his Pasadena Art Museum exhibition, 1974.

Post-1950 Paintings, PAM, July 25–September 3.

Southern California Attitudes, 1972, PAM, September 19–November 5. Artists include John Baldessari, Michael Olodort, and Alexis Smith.

Graphics of the Sixties, PAM, September 9–October 29.

Gifts of Mr. and Mrs. Edward C. Crossett, PAM, November 7–January 7.

1973

PAM Staff

President of the Board of Trustees—Alfred Esberg
Director—William Agee
Music Director—Robert Turner
Curator of Painting and Sculpture—
 Barbara Haskell
Curator of Design—Eudorah Moore

Local and Museum Events

March 1, 1973: Pasadena Art Museum changes its name to the Pasadena Museum of Modern Art (PMMA) to reflect the emphasis of its exhibitions and collections.

April 26–30: Chris Burden executes his *Locker Piece,* in which he spends five days in a locker at the University of California, Irvine.

Kenneth Tyler leaves Gemini, G.E.L., in Los Angeles and founds Tyler Graphics Ltd. in New York.

The final Encounters Series concerts at Caltech include performances by Paul Chihara, Mario Davidovsky, and Salvatore Martirano.

Special Events Held at PAM

February 13–March 20: Screening of Kenneth Clark's new series of films, *Pioneers of Modern Painting.*

February 25: Repertoire Chamber Orchestra Concert.

May 1: Walter Hopps gives a lecture on the Los Angeles art scene during the 1950s and 1960s: *Looking Back—What Happened and What Didn't?* PMMA.

Robert Rauschenberg is commissioned by the Men's Committee to create a new graphic work, *Horsefeathers 13–IX.*

September 23: George Herms and Petrie Mason present an original theater piece entitled *Streaming.*

October 17: Photographers Barbara Morgan and Robert Heinecken lead a panel discussion on the future of photography.

November 15: *Playboy* centerfold photographer Mario Casilli gives a lecture entitled *Lighting, My Greatest Tool.*

December: Men's Committee commissions Jirayr Zorthian to create a new graphic work entitled *Death of Piggy II.*

Selected Local Exhibitions

Master Photographers: Ansel Adams, Wynn Bullock, and Edward Weston, organized by Fred Parker, PMMA, January 30–March 25.

New Talent: Amsterdam, Paris, Dusseldorf, organized by the Solomon R. Guggenheim Museum, PMMA, February 20–April 8. Exhibition designed to acquaint the Southern California public with a number of foreign-based artists whose work has never been exhibited on the West Coast before.

Agnes Martin, PAM, April 3–July 31.

Pablo Picasso: October 25, 1881–April 8, 1973, PMMA, April 20–June 3.

A Look at New York, organized by Barbara Haskell, PMMA, June 12–July 22.

Market Street Program, PMMA, July 31–
September 2. Experimental exhibition with works
selected via questionnaire and computer. Featuring
works by Peter Plagens and four Bay Area artists.

Eva Hesse Memorial Exhibition, organized by
the Solomon R. Guggenheim Museum, PMMA,
September 18–November 11.

Claes Oldenburg, "Notes", PMMA, October 2–
January 13.

Jules Olitski Retrospective, organized by the Museum
of Fine Arts, Boston, PAM, November 27–
January 13.

1974
PAM Staff
President of the Board of Trustees—Gifford Philips
Director (until March)—William Agee
Administrative Director—Carol Marsden
Director of Exhibitions and Collections—
 Barbara Haskell
Curator of Design—Eudorah Moore

After April
President—Norton Simon
Director—George Peters

Local and Museum Events

The Pasadena Art Museum's fiftieth anniversary.

February: The Men's Committee commissions
Ellsworth Kelly to create a new lithograph at
Gemini G.E.L. entitled *Blue over Red–Orange.*

April: The museum's name is changed back to the
Pasadena Art Museum.

April: Norton Simon accepts the trustees' request
to intervene and forestall the financial collapse
of the museum. Simon's collections are exhibited
with those of the museum.

June 24–March 1, 1975: Galleries are closed for
renovation.

Selected Local Exhibitions

Ellsworth Kelly Retrospective, organized by the
Museum of Modern Art, PMMA, January 15–
March 3.

Kasimir Malevich, 1878–1935, organized by the
Stedelijk Museum, Amsterdam, PMMA, January 28–
March 25.

Llyn Foulkes: A Survey Exhibition, 1959–1974,
Newport Harbor Art Museum, Newport Beach.

John Mason Retrospective, organized by Barbara
Haskell, PAM, May 7–June 23.

1975
Norton Simon Museum Staff
President—Norton Simon

Local and Museum Events

March 1: The reorganized Pasadena Art Museum
reopens. Dance and art class studios are converted
to gallery space, the restaurant is closed, and the
Pasadena Art Workshop relocates to another site.

October: The Pasadena Art Museum is renamed
the Norton Simon Museum of Art.

February 1977: Additional space for temporary
exhibitions opens on the lower level.

1988
Major long-term loans of the Norton Simon
Museum's contemporary collection to the Los
Angeles County Museum of Art's new Anderson
building and to the Museum of Contemporary
Art, Los Angeles.

1989
The Pasadena Art Workshops move to 145 N.
Raymond Ave. and, with the addition of a gallery
program, become the Armory Center for the Arts.

1993
June 2: Norton Simon dies at age eighty-six.

1996–Present
Norton Simon Museum Staff
President—Jennifer Jones Simon
Executive Vice-President—Walter Timoshuk
Director of Art—Sara Campbell
Curator of Art—Gloria Williams

The galleries and gardens of the Norton Simon
Museum of Art undergo renovation. Renowned
architect Frank Gehry designs the gallery modifi-
cations, and Nancy Power is the landscape
architect for the gardens.

Related Events: Performances, Panel Discussions, and Lectures

All events take place at the Armory Center for the Arts unless listed as One Colorado.

Sunday, February 14, 5 p.m.
Concert: Music of Stockhausen
Southwest Chamber Music

Saturday, February 20, 8 p.m.

Concert: Music of Young,
Partch, Lesemann, and Harrison
and Gamelan Court Music
Southwest Chamber Music

Sunday, February 21, 5 p.m.

Concert: Music of Wolff and Feldman
Southwest Chamber Music

Thursday, February 18, 7 p.m.

An Evening with Llyn Foulkes
New Pasadena Gallery, One Colorado

Thursday, February 25, 7 p.m.

Panel on Artists in Pasadena,
1960–74, featuring artists in
the exhibition
New Pasadena Gallery, One Colorado

Thursday, March 4, 7 p.m.

An Evening with Suzanne Muchnic
New Pasadena Gallery, One Colorado

Friday, March 5, 8 p.m.

Friday Forum: An Evening with
Leonard Stein

Saturday, March 13, 8 p.m.

Concert: Music of Messiaen and
Stockhausen and Indian Ragas
Southwest Chamber Music

Sunday, March 14, 5 p.m.

Concert: Music of Crumb,
Boulez, and Cage
Southwest Chamber Music

Friday, March 26, 8 p.m.

Friday Forum: Panel on
Contemporary Art in Pasadena,
1960–74, featuring art educators,
exhibition artists, and curators

Friday, April 2, 8 p.m.

Friday Forum: Art Performances by
Barbara Smith and John White

Friday, April 9, 8 p.m.

Open Rehearsal: Cage's
Atlas Eclipticalis
Southwest Chamber Music

Saturday, April 10, 8 p.m.

Concert: Music of Cage and Babbitt
Southwest Chamber Music

Sunday, April 11, 7 p.m.

Concert: Music of Lennon /
McCartney, Berio, and Berberian
Southwest Chamber Music

All concerts repeated at Zipper Concert Hall, Colburn School of Performing Arts, 200 South Grand Avenue, Los Angeles.

Index of Artists